Wallasey

From Old Photographs

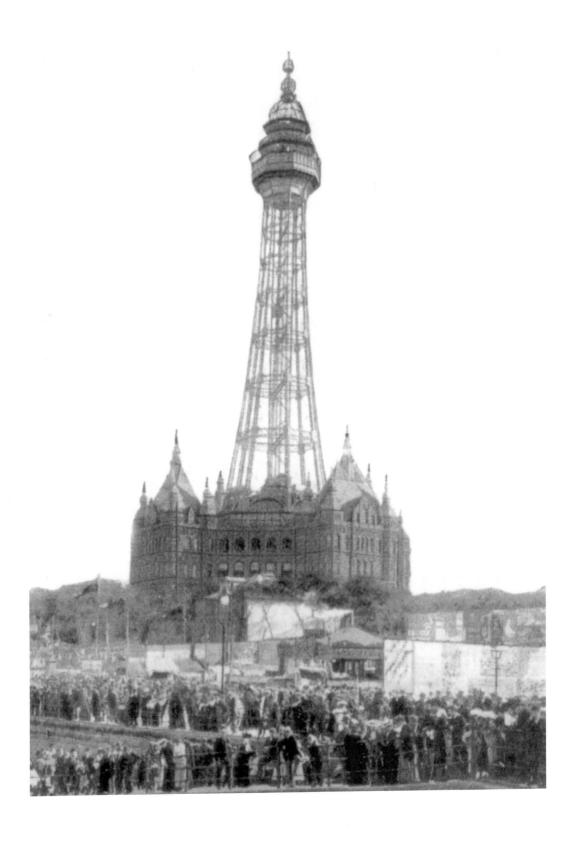

Wallasey
From Old Photographs

By Ian Collard

AMBERLEY

Frontispiece: New Brighton Tower.

First published 2009

Amberley Publishing Plc
Cirencester Road, Chalford,
Stroud, Gloucestershire, GL6 8PE

www.amberley-books.com

British Library Cataloguing in Publication Data.
A catalogue record for this book is available from the British Library.

isbn 978 1 84868 284 9

Typesetting and Origination by Diagraf (www.diagraf.net)
Printed in Great Britain

Contents

ACKNOWLEDGEMENTS

I wish to thank K.J. Clark for allowing me to use images from the collection of his uncle, James Rogers, who died in 2005, after recording life in the County Borough of Wallasey for many years. His photographs cover most aspects of work, recreation and leisure in the town, and he has captured many buildings and institutions that have long disappeared.

James Rogers spent his childhood and early years living in New Brighton, where he went to school. He married May Clark sometime during the war years, when he was and aircraft fitter and engineer at an airfield in Yorkshire. After the war he and James Clark decided to start their own printing business, forming the 'Belvidere Press', situated in Rake Lane. Both men had outside interests and both gave talks to various groups: James Rogers on old Wallasey and his early experiences, and James Clark on wind and water mills. James Clark died in 1990 and his partner continued the business until about 1995, when changes in technology and his increasing age made retirement a sensible option. He remained active with his talks on Wallasey and war stories until his death in 2005, when his nephew, Ken, acquired his slides and decided to take over his talk as well as that of his father.

There are also photographs from other collections some of which I have been unable to trace, which have been invaluable as part of a record of Wallasey over the past one hundred years. I must also thank Alan Brack, E. Cuthbert Woods and P. Culverwell Brown, Ken Mc Carron, Merseyside Portfolios, the Wallasey History Society and the Workers' Educational Association.

INTRODUCTION

Although I was born and brought up in Birkenhead, we tended to spend most of our summer weekends in the 1960s at New Brighton. This was the period when the resort was very busy with visitors arriving from other parts of Merseyside and the Lancashire and Cheshire towns.

The trains and ferries brought people to enjoy a day on the beach or to spend their money in the swimming baths, amusement arcades, fairground or in the many shops in Victoria Street. The town was very popular, with many visitors staying for long weekends or even a fortnight.

However, the County Borough of Wallasey also contained Seacombe, Liscard, Wallasey Village, Leasowe, Poulton, Egremont and Moreton, all of which developed from small settlements. As the dock system acts as the boundary with Birkenhead, the river and the sea on two sides of the peninsula, the town has been compared with an island,

The Mersey ferries helped Wallasey develop as a popular residential area in the nineteenth and early twentieth centuries, when people like James Atherton developed the area with affordable homes and facilities. New Brighton Tower, which was 100 feet higher than Blackpool Tower, opened in 1901 following the completion of the fairground.

The town was granted County Borough status in 1913, and the foundation stone for a new town hall was laid by the King the following year. Wallasey became a Parliamentary Borough in 1918, and the sea defences were extended and improved. The importance of good communication was recognised, and the road and rail network were developed. The Mersey Railway and Kingsway Road Tunnel helped to provide vital transport links across the conurbation of Merseyside.

Although much of the seaside resort facilities have now disappeared, there are plans to bring the ferry back to New Brighton. There are also plans to redevelop the dock system with offices, hotels, apartments, shops and other leisure developments. It will be interesting, therefore to record the changes that are proposed for Wallasey over the next few years.

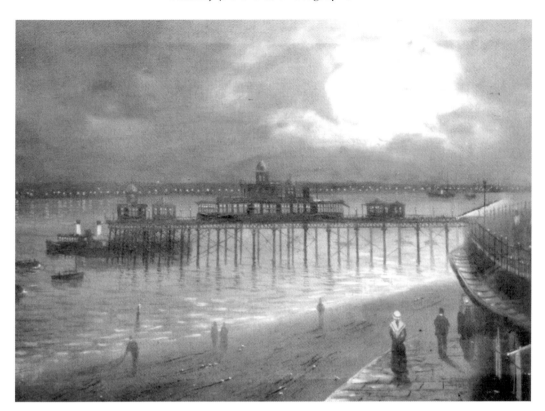

New Brighton Pier and Ferry.

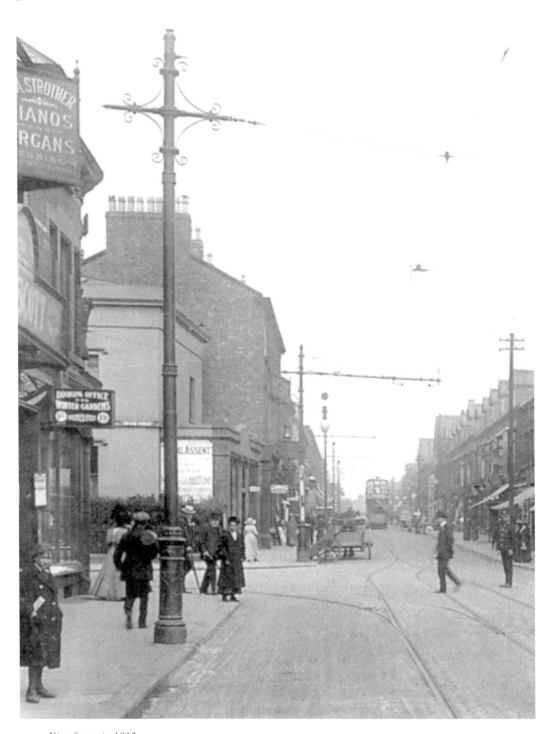

King Street in 1912.

Chapter 1

WALLASEY

The name Wallasey originates from the Germanic word *Walha*, which means stranger or foreigner, and is also the origin of the name Wales. The first authentic record of Wallasey is in the Doomsday Book of 1086, where it stated that the Saxon landowner, Ulstred, had been dispossessed of his lands. These were awarded by William I to the Earl of Chester, and were then held by Robert de Rodelent. Wirral is a peninsula rather than an island, the Irish Sea, River Mersey and the Dee forming the main boundaries. When the Romans arrived around AD 74, they found a Celtic tribe, the *Carnavii*, controlling the area including Wirral. The peninsula was known as *Kilguri* and was occupied until the beginning of the fifth century, when the Romans withdrew from Britain. The Anglo-Saxons were in control of most of the area by AD 613, and they established and named many small settlements, such as West Kirby, Frankby and Irby. However, by the end of the ninth century the Norsemen arrived from Ireland.

The area consisted mainly of sandhills, and the people had a reputation for smuggling and wrecking, building secret underground cellars and tunnels. Fires were built on the shore to attract ships near the Burbo and Hoyle sandbanks where they would go aground. Salt, sugar, rum and tobacco were smuggled onto small boats and landed at Wallasey. As late as 1839, the *Pennsylvania* and two other ships were wrecked off Leasowe in a storm and their cargoes and remains were taken from the beach by the local residents.

Mother Redcaps was built in 1595 by the Mainwaring family, just above the water line of the Mersey between Egremont and New Brighton. The building was passed to the Davis family and was bought by Mrs Maddock in 1862. The front door was five inches thick, with evidence of a trap door inside which led to the cellar, so an intruder would fall eight or nine feet. The cellar was reputed to contain several secret compartments where smuggled goods were hidden from the police and Customs & Excise officers.

The peninsula was consisted mainly of woods, marshland and small farming and fishing communities. In the sixteenth and seventeenth centuries horse-races were organised on Leasowe sands by the Earls of Derby, and these are regarded as the forerunners of the Derby races. Gunpowder from ships entering the port was deposited in a magazine near the beach. It was also recognised that one of the main dangers to shipping entering the river was the Black Rock, and a 'perch', or wooden pole set into the riverbed, was erected there in 1683. An Act of Parliament was passed in 1761 to enable lighthouses to be erected at Leasowe and Hoylake, and a light was erected on Bidston Hill in 1771.

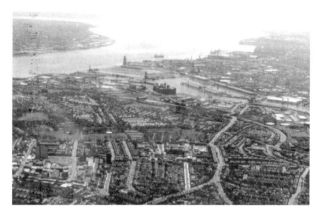

Wallasey and the Docks.

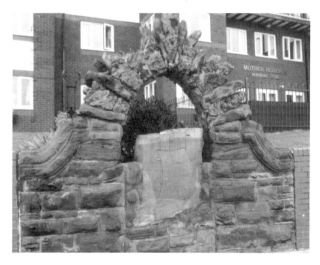

Mother Redcaps.

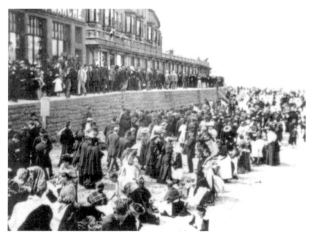

The Ham & Egg Parade, New Brighton.

14

In 1796 a French invasion of Ireland was averted by a combination of the Royal Navy and a very bad storm. The news of this caused a flood of volunteers in Liverpool, and troops were sent to the town which was quickly transformed into an armed military camp. A temporary battery was placed on the Red Noses at the entrance to the river on the Wirral side which guarded the Rock Channel, and another battery was installed near the Perch Rock.

Following another attempt by the French to invade Ireland, an Act of Parliament was passed in 1798 to enable money to be raised to protect 'from an inveterate enemy'. The following year all vessels that sailed from the Mersey were armed, and their crews were experienced fighting men. Following several years of relative peace between Britain and France hostilities erupted again in 1803, and King George III asked the local merchants to contribute to the building of a new battery at Perch Rock and the provision of a fleet of gunboats to protect ships entering and leaving the River Mersey.

Consequently, by 1805 the river was defended by the provision of twenty-eight guns at the Red Noses and in Liverpool. A battery mounting seven guns at Perch Rock was proposed by the Royal Engineers in 1814, but Wellington's victory the following year reduced the immediate need for this protection. In March 1821 a severe winter storm demolished the beacon and the Liverpool Corporation surveyor suggested that a lighthouse be built. However, it wasn't until the beacon was swept away again in 1824 that the suggestion of a permanent light was taken seriously and action was demanded by the Liverpool Ship Owners Association.

Captain John Kitson of the Royal Engineers was given the task of planning the battery, and he also looked at the need for a lighthouse at the entrance to the river. Construction of the fort began in 1825, and it was completed on 30 April 1829. The foundation stone for the lighthouse was laid on 8 June 1827 by the Mayor of Liverpool. and a temporary light was anchored near the rocks in 1826 which operated each winter until the lighthouse became operational on 1 March 1830.

St Hilary's church was completed in 1857 to replace the previous church, which was built in 1730. It has is that there has been a church on the site since the fifth century and three of these have been burnt down. The tower still standing next to the present church dates back to 1530; the accounts of the parish date back to 1658 and the registers to 1574.

James Atherton, a Liverpool merchant, purchased around 170 acres of land at Rock Point in 1830 in order to develop it as a small town of residential homes, with a church, hotel and ferry to Liverpool. The gunpowder magazine was closed in 1851 and houses were built on the slopes with views of the river and Liverpool. The 'Ham & Egg Parade' was opened in 1872 when New Brighton was begining to develop as a popular seaside resort for people from Liverpool and the Lancashire towns. A ferry pier was opened in the 1860s, and a promenade built from Seacombe to New Brighton at the end of the century.

Atherton had also founded the New Brighton ferry, with his son-in-law, William Rowson, in 1830, and they also constructed a timber pier. Edward W. Coulbourn purchased the ferry in 1850. The Coulbournes lived at the family home at The Grennan in St Georges Mount and could see the ferries from their house. It was claimed that one of the Coulbourn brothers inspected the loading of passengers at Egremont then rode down the beach to see them disembark at New Brighton. The ferry service was purchased by the Local Board in 1860 and William Carson was appointed manager the following year. The pier at New Brighton was rebuilt and re-opened in 1867.

The ferries enabled people to move and settle on the Wirral side of the river, and residential developments along the riverside brought people from Liverpool to live. New Brighton also developed into a popular seaside resort in the latter half of the eighteenth century, and the New Brighton Tower was opened in 1900. With the opening of the Mersey Railway in 1886 the

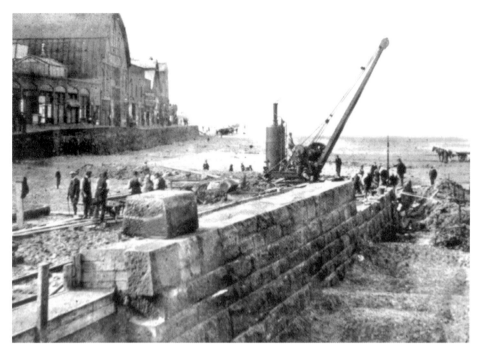

Construction of the Promenade at New Brighton.

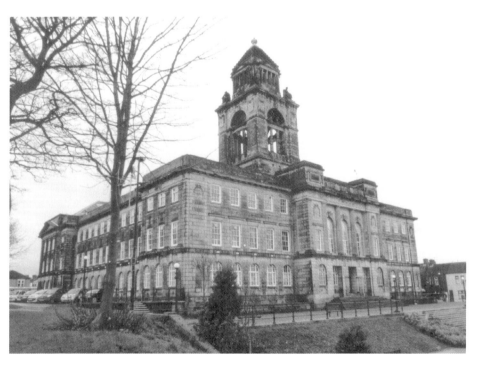

Wallasey Town Hall.

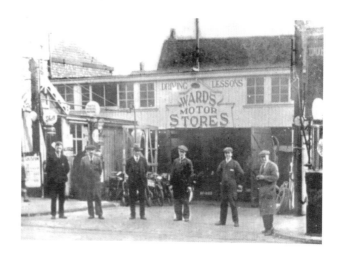

Ward's Garage and Driving School.

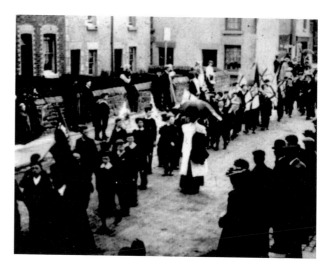

Wallasey Village Festival Procession,
1901.

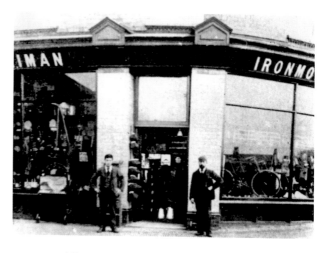

Berriman's Iron Monger in Rake
Lane.

housing development in Wallasey increased, and Egremont, Liscard, New Brighton, Poulton, Seacombe and Wallasey Village gradually merged together to form Wallasey.

The 'Ham & Egg Parade' at New Brighton was a narrow promenade that contained eating houses, each of which tried to encourage the visitors to use their premises. It was known as an place of drunkenness and fighting. The Council acquired the Parade in 1905 and a sea wall was built along the Marine Promenade.

The Urban District Council came into existence under the Local Government Act 1894, and the area was divided into eight wards, with representatives elected for each ward. A petition was lodged in 1902 for application as a Borough to appoint a Mayor, Aldermen and a Town Clerk and to establish a police force.

However, it was not until 1910 that this was achieved, by Royal Charter granted by King George V. The wards were increased to ten, with ten Aldermen and thirty Councillors meeting for the first time on 11 November 1910, and County Borough status being granted in 1913.

Although the foundation stone for the new Town Hall was laid by the King on 25 March 1914, it was not opened until November 1920 as it had been used as a military hospital during the First World War. Wallasey also became a Parliamentary Borough in 1918. Parliamentary sanction was obtained in 1927 to extend the promenade from New Brighton to Harrison Drive. A concrete wall was built on reclaimed land and work commenced in 1931. Many local residents and politicians had argued that the money would have been better spent by creating a Wallasey link to the new Mersey Tunnel. However, work continued on the new promenade, swimming pool and boating lake, and it was opened in 1939. The District of Moreton had been added to the borough in 1928. With the introduction of the Mersey Railway in 1886, Moreton became a popular residential area and was recommended as a place to live because of its fresh air and clean sea. The Liverpool Open-Air Hospital was built for children with tuberculosis. In 1974, as part of local government reorganisation, Wallasey became part of the Metropolitan District of Wirral.

Mother Redcaps in the 1960s.

18

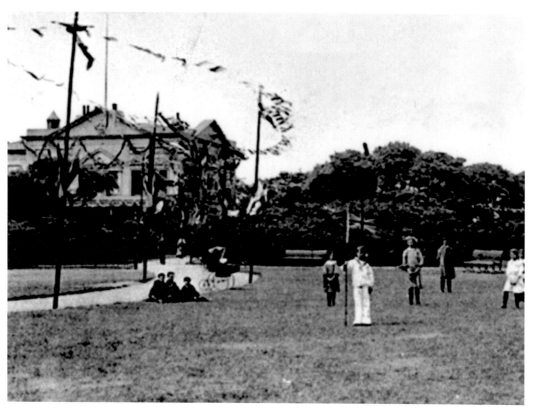

Liscard Hall was built in 1835 by Sir John Tobin, a member of an important Isle of Man family. He was born in 1762 to Patrick Tobin and later went to sea as an apprentice. On his first sea-going voyage he was captured by a French privateer but was later released, unharmed. In 1797 he took command of the privateer Molly, which carried 436 slaves. He captured three French ships carrying cargo and slaves.

He married the daughter of James Aspinall in 1789 and lived in Old Swan, Liverpool. When he retired from the sea at forty years of age, he was a very rich man and continued with the business of privateering and slave trading. He became the Lord Mayor of Liverpool in 1819 and was knighted the following year. In 1823 he had a public quarrel with the Parry Brothers, who were the lessees of the Seacombe Ferry, and he was taken to court.

In 1828 he bought land on the banks of Wallasey Pool, and the following year he gave 7,000 square yards of this land and £1,000 towards the building of St John's Church. His son, John, was appointed the first minister of the church, his duties being to conduct a minimum number of services and to visit the sick. Liscard House was built in 1833 for John Tobin, and Liscard Hall constructed in 1835. Sir John also owned a fishing lodge at the edge of the River Mersey, where he moored the yacht he used to cross the river.

One of Sir John's daughters became Mrs James Cockshott, and another became Mrs Reddie, the wife of the Governor of the Isle of Man. The third daughter married Harold Littledale who created a model farm in Wallasey. Sir John built and owned the steamship Great Liverpool in 1838. He died on 27 February 1851 and is buried in St John's churchyard. The commander of the Artic whaler Baffin honoured him by naming Cape Tobin after him after surveying the coast of Greenland.

Liscard Hall was left to Harold Littledale, who died in 1889. The hall and grounds were purchased by the Wallasey Local Board and opened to the public, becoming Central Park. The hall later became a school of art, and the Home Guard shared the accommodation during the Second World War. The Grade II building later became Wirral Metropolitan College, then Serve Wirral and was destroyed by fire in 2008 and demolished.

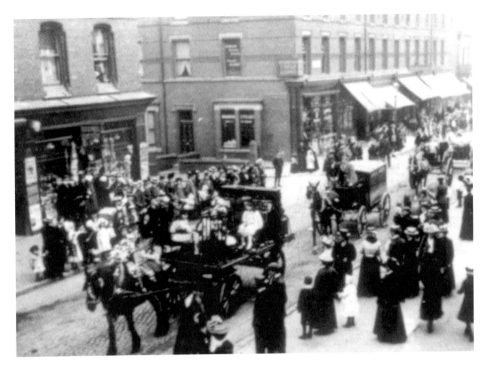

May Day Procession in 1901.

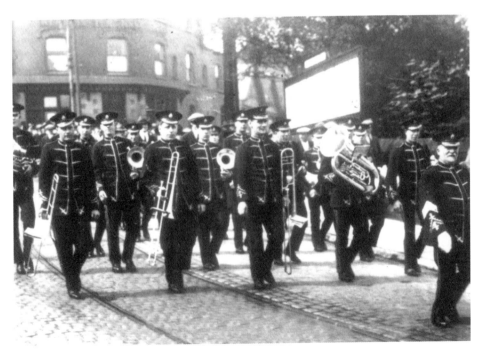

Wallasey Silver Band in 1929.

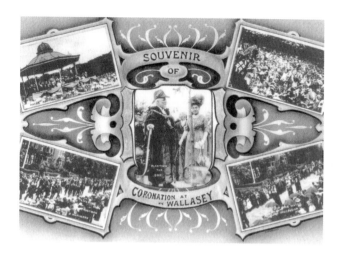

Souvenir of the Coronation of King
George V and Queen Mary in 1911.

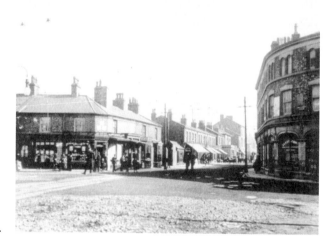

The centre of Liscard Village in 1900.

Brush Castle is shown on a map of
1841 as 'Marine Villa', owned by
John Astley Marsden who was a
brush manufacturer of Liverpool.
It was called Brush Castle and was
situated near the end of Seaview
Road, in spacious grounds and
surrounded by trees. It was left to
decay and was finally demolished in
1902.

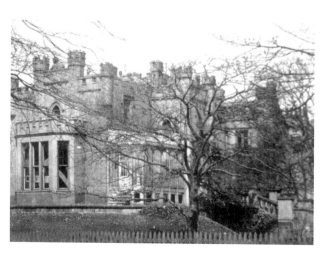

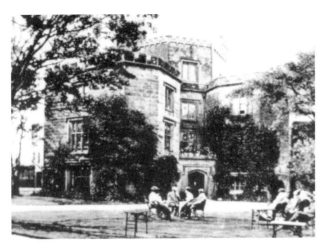

Leasowe Castle dates back to 1593, when it was built by Ferdinando, fifth Earl of Derby. The building originally consisted of an octagonal tower four stories high, with windows on each side, surrounded by a flat lead roof. It is believed that the tower was either used by the Earl and his guests as a private stand for watching horse racing on a course, or to watch hawking. Turrets were later added and it became a residence used by William, sixth Earl of Derby, in 1640. It was later known as Mockbeggar Hall and used as a farmhouse. Mr Egerton of Oulton lived there until his death in 1786, and in 1818 alterations and additions to the building were made by Mrs Boode, daughter of the Rev. Thomas Dannett, rector of Liverpool. Margaret Boode allowed the house to be used at times as a hospital for the survivors of shipwrecks on the coast. She was killed in a carriage accident on 21 April 1826 and a monument was erected where she died in Breck Road at Poulton. Her daughter, Mary Anne, married Colonel Edward Cust in 1821, and she became an assistant to Queen Victoria's mother, the Duchess of Kent. Cust proposed the development of a holiday resort at Leasowe with holiday homes to be built with a view of the sea. The plans, however, failed to materialise, and General the Hon. Sir Edward and Lady Cust used the Castle as their country home until it was sold in 1895 and converted into the Leasowe Castle Hotel. In became a convalescent home for railwaymen in 1908, and was used by German prisoners during the First World War. It was closed in 1970 and was empty for some years until it was reopened and restored in 1982 as the Leasowe Castle Hotel.

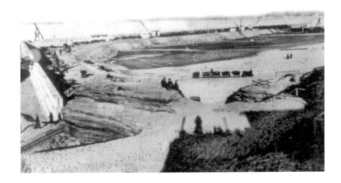

Construction of promenade extension at Harrison Drive in 1931.

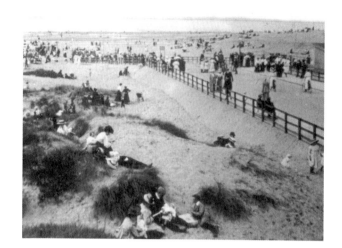

The sandhills at Harrison Drive.

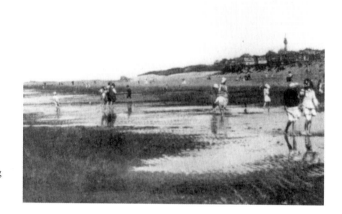

The shore at Harrison Drive looking towards the Red Rocks and New Brighton.

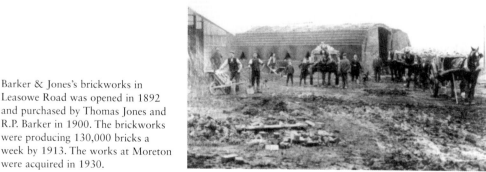

Barker & Jones's brickworks in Leasowe Road was opened in 1892 and purchased by Thomas Jones and R.P. Barker in 1900. The brickworks were producing 130,000 bricks a week by 1913. The works at Moreton were acquired in 1930.

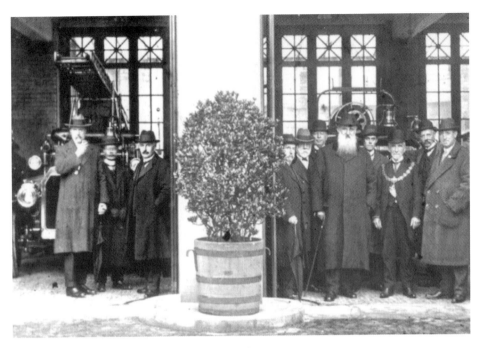

Local politicians and dignitaries pose outside Liscard Fire Station.

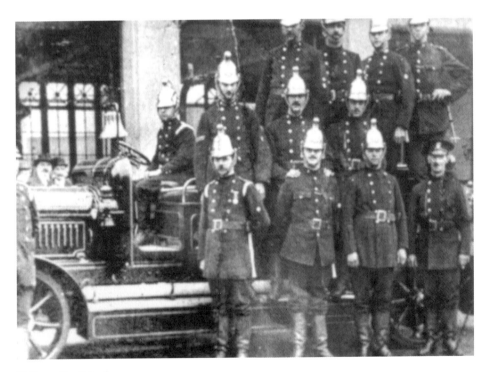

Wallasey Fire Brigade.

Above and below: Two views of trams in Liscard Road.

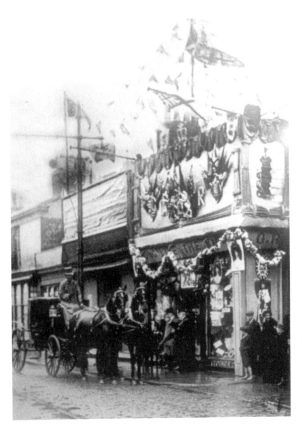

Left: The Mayor's carriage stands outside shops decorated for the Coronation of King George V and Queen Mary on 22 June 1911.

Below: A view of Wallasey Village.

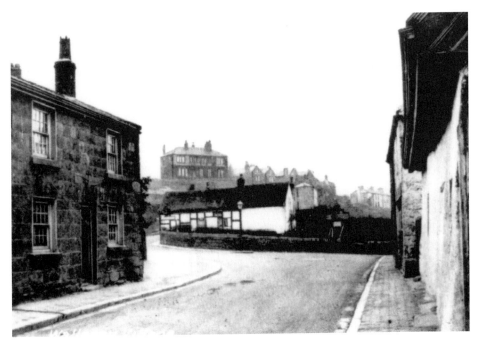

Victoria Central Hospital in Liscard Road. The foundation stone was laid on 6 July 1899 after a fundraising event raised over £6,000. The hospital was opened on 1 January 1901 and was funded by public subscription and contributions. It became part of the National Health Service in 1948, and an extension to the building was completed in 1957. The hospital was closed in 1982.

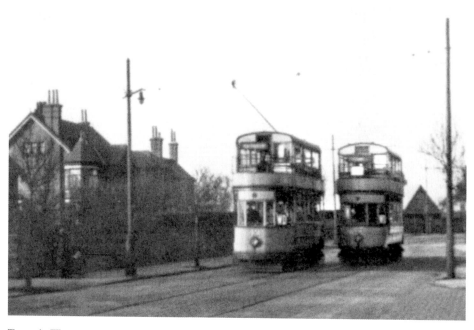

Trams in Warren Drive in 1931.

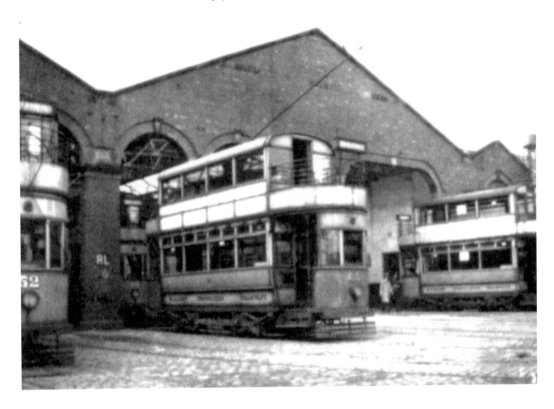

Above: Seaview Road Tram Depot in 1933.

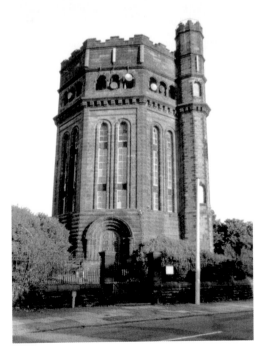

Left: The New Brighton Water Tower in Gorsehill Road was opened in 1905. The first reservoir was completed in 1887 and the second at the same time as the tower. The two reservoirs have a capacity of over six million gallons. They are fed by local water and a supply from Lake Vyrney in North Wales. In May 1941 they were damaged by a high-explosive bomb, but they were not fully repaired until 1948.

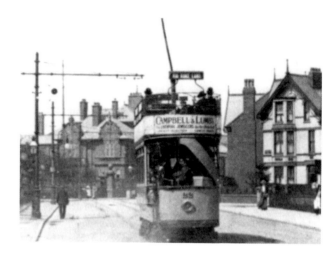

The Rake Lane tram heads along Liscard Road past Victoria Central Hospital.

A tram navigates around the centre of Liscard Town Centre in 1913.

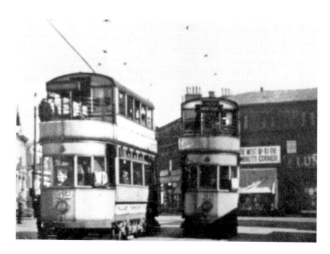

Wallasey Corporation trams Nos 52 and 88 at Liscard in 1933.

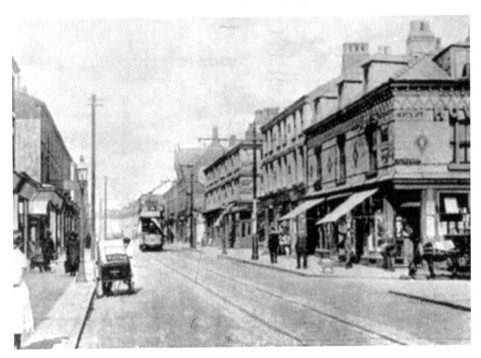

An early morning view: the shops begin to open in Brighton Street.

Another view of Brighton Street dressed in bunting for the royal visit in 1914.

The grave of Captain Stanley Lord who is buried in the main cemetery in Wallasey with his wife, Mabel, and son, Stanley. Captain Lord died on 24 January 1962, aged 84 years. He was born on 13 September 1877 in Bolton, Lancashire, and began his training at sea in 1891, when he was thirteen, aboard the barque Naiad. He gained his Second Mate's Certificate and in 1901, and at the age of 23 he obtained his Master's Certificate. Lord began his seagoing service with the Pacific Steam Navigation Company, who were taken over by the Leyland Line in 1900. He was given his first command in 1906, becoming master of the *Californian* in 1911.

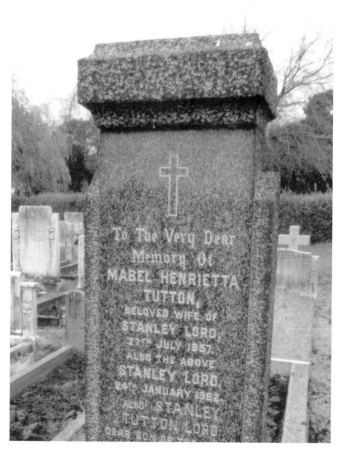

On the evening of the 14 April 1912 the *Californian* approached a large ice field, and Captain Lord decided to wait until the following day to proceed, telling his wireless operator to warn other vessels in the area about the ice. The wireless officer remained on duty until 23.30, when he went to bed. During the night the officer on watch on the bridge saw rockets being fired and Captain Lord was awakened but assumed they were company rockets. Morse signals were sent from the *Titanic* but the officer on watch on the *Californian* decided not to wake the wireless operator. It was decided that no one should wake up the wireless operator, and when the lights disappeared it was thought that the vessel had left the area.

In the inquiries following the sinking Captain Lord said that the *Californian* had attempted to contact *Titanic* by Morse lamp several times around midnight, but the liner did not reply. The enquiries found that the *Californian* was much closer to the *Titanic* than the 19½ miles Captain Lord believed, and that he should have awoken the wireless operator and thus could have acted to prevent the loss of life. Stanley Lord resigned from the Leyland Line in August 1912. He joined the Nitrate Producers Steamship Company in 1913, where he remained until 1928, when he resigned on health grounds. In 1958 the Mercantile Marine Service Association petitioned the Board of Trade in an attempt to clear his name.

When the wreck of *Titanic* was discovered in 1985, it was confirmed that the position given by her officers was inaccurate. There was a conflict of interest at the two enquiries in 1912 about the true position of *Titanic* when she sank. Both enquiries had made the assumption that the position Captain Lord had given for his ship was incorrect and that he was closer than he claimed. Consequently, the actual position of the wreck on the seabed disputes the accuracy of both enquiries conclusions on the circumstances surrounding the sinking of the *Titanic*.

In 1988 when the Marine Accident Investigation Branch looked at the conclusions of the two earlier reports and the later evidence, they had difficulty in making any new conclusions. However, they felt that *Titanic's* rockets had been seen by the *Californian* and should have been investigated but could not agree if both ships were ever in sight of each other.

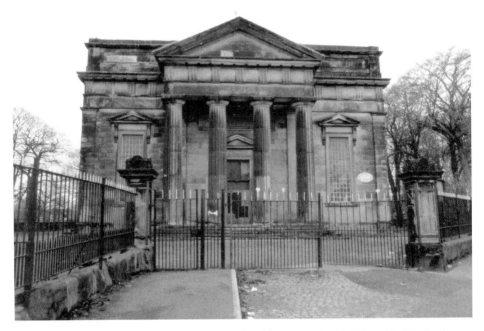

St John's Church was opened on 19 May 1833 and could accommodate 1,500 people. The land once belonged to Birkenhead Priory and (as mentioned) was purchased by Sir John Tobin from F.R. Price. It was renovated on its centenary in 1933 and was bombed in 1941, causing damage that was not repaired until 1954.

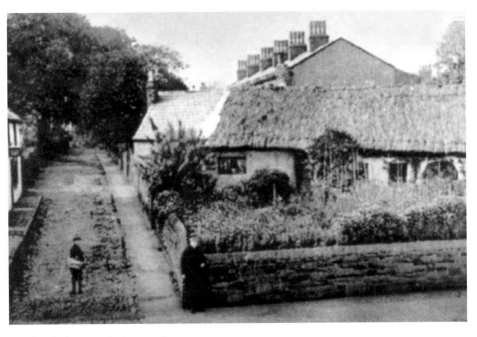

The thatched cottages in Egerton Grove.

Mosslands House, surrounded by agricultural land.

A view of Grove Road Station taken from the sandhills in 1905.

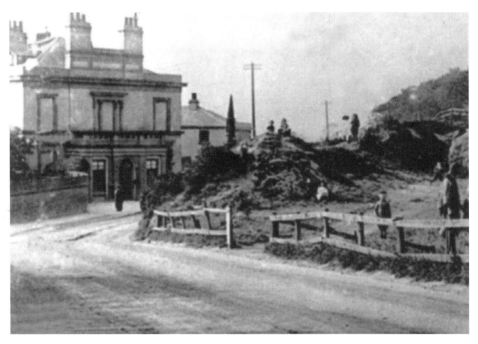

Children play on the land opposite Darley Dene House on Breck Lane. Darley Dene was originally known as the Slopes, and was built for Mr Monk of Monk & Newall contractors. It was used as military accommodation during the Second World War and was bombed on 12 March 1941, killing some soldiers and injuring others. The outer walls remained until 1959, when they were demolished.

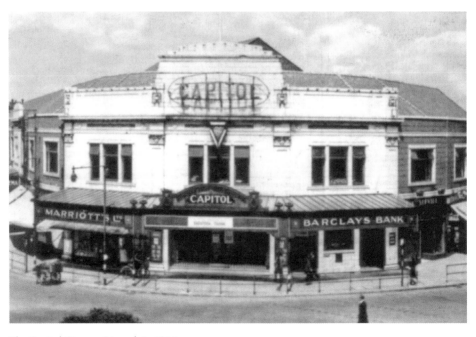

The Capitol Cinema, Liscard, in 1946.

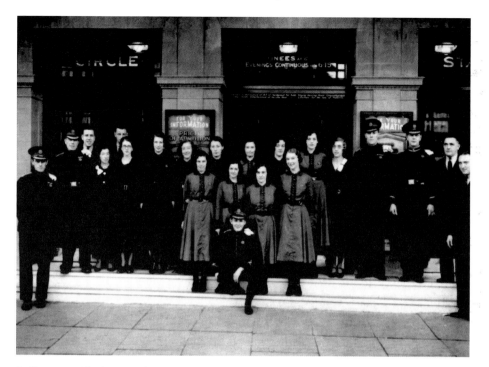

Staff pose outside the Capitol Cinema.

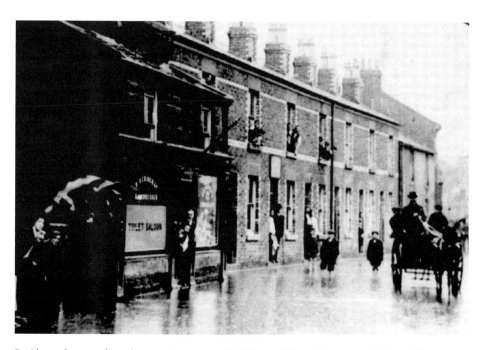

Residents clear up after a heavy rainstorm at 468 Wallasey Village. This part of Wallasey Village was susceptible to flooding until a new drainage system was installed.

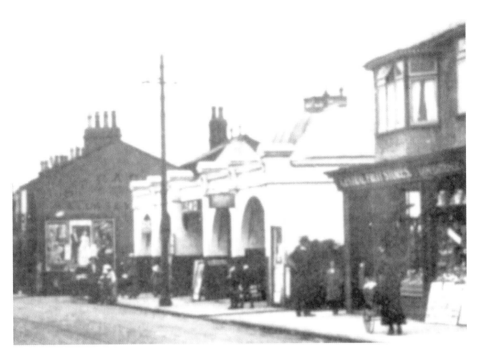

The Cosmo Cinema at Wallasey Village in 1916.

The Alexandra Tea Rooms in Tobin Street.

Martins Lane.

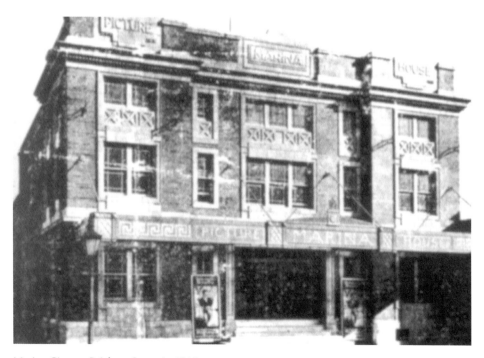

Marina Cinema, Brighton Street, in 1916.

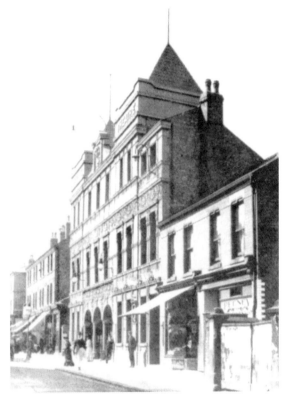

Left: The Irving Theatre in 1906.

Below: The Liverpool Home for Aged Mariners was built by William Cliff, a Liverpool merchant, in memory of his daughter Rosa Webster. The main building was surrounded by a tower 135 feet high which contained a clock and bell. It was closed in 1977 and has since been demolished. There is now a small estate of bungalows, flats and houses on the site for mariners and their widows.

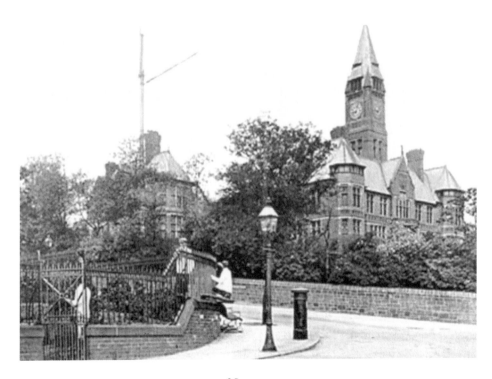

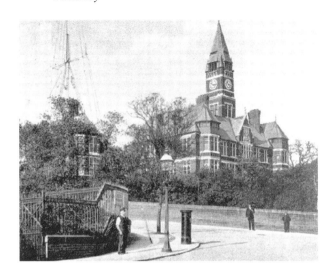

The Mariners Home in 1920

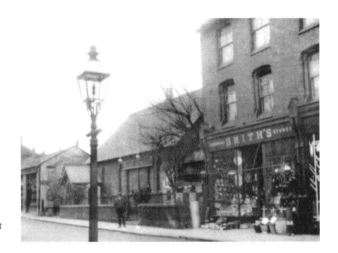

Smith's Hardware & General Store at Wallasey Village in 1905.

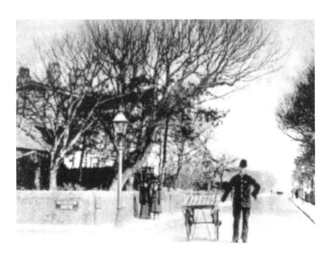

The junction of Grove Road and Harrison Drive.

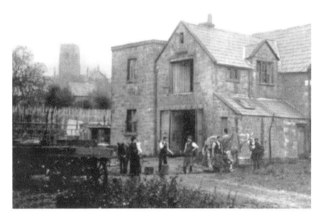

School Lane Smithy in 1920, built on the site of St Hilary's School.

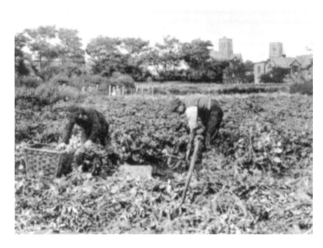

Farm workers tend crops in the fields opposite School Lane.

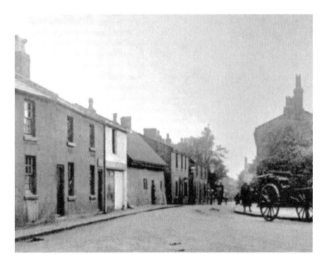

Coal is delivered by horse-driven cart to the southern end of Wallasey Village.

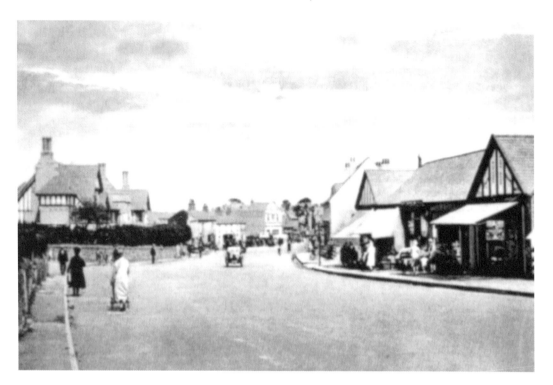

Above: A lone vehicle drives down Hoylake
Road at Moreton towards Meols.

Right: An Act of Parliament was passed in
1761, authorising the building of four lights to
assist vessels passing up the Rock Channel to
the Mersey. Leasowe light was originally named
the 'Upper Mockbeggar', and it survived until
1824 when the present lighthouse was built.
The lighthouse keeper in 1908 when it was
decided to close the lighthouse was Mrs Mary
Elizabeth Williams, who lived there with her
thirteen children. She had been responsible for
the day-to-day operation of the lighthouse for
fourteen years, since her husband became ill and
she took over his duties. When the building was
closed Mrs Williams opened it as a tea-room,
and the family continued to live on the first and
second floors. The lighthouse was purchased by
Wallasey Corporation in 1930 for £900, and it
was closed in 1935 after Mrs Williams died.

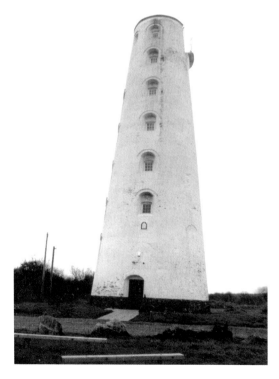

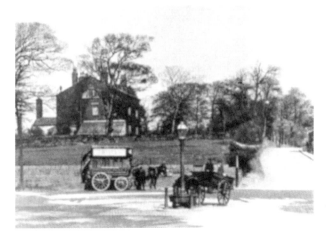

The junction at Mill Lane and Poulton Road.

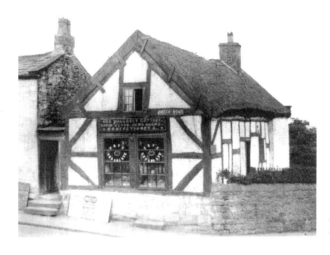

Old Wallasey Cottage Newsagent & Confectioner in Breck Road.

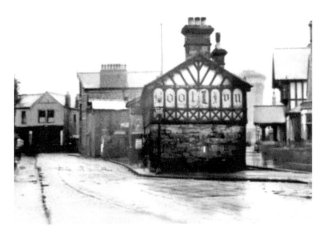

There has been a public house on the site of the Boot Inn since Elizabethan times. The building shown has since been demolished in order to build the present public house.

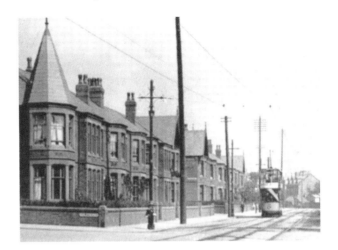

A tram drives along a deserted Rake
Lane.

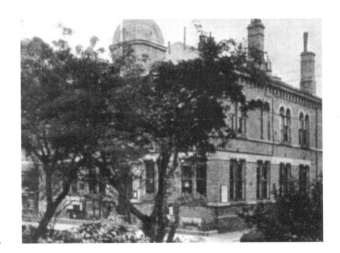

The old Town Hall in Church Street.

A horse and carriage in Breck Road.

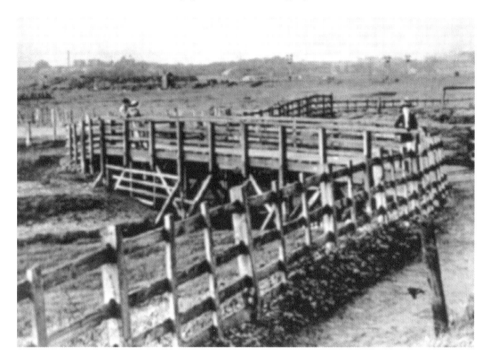

View of Bidston Moss.

Breck Road with Bidston Moss in the distance.

Right: 'Nelson's Gutter' was the original name of School Lane. The old stonehouse on the site of Stonehouse Lane had a plate on the wall, inscribed 'Stonehouse, 1693'.

Below: The Old Nags Head in 1960.

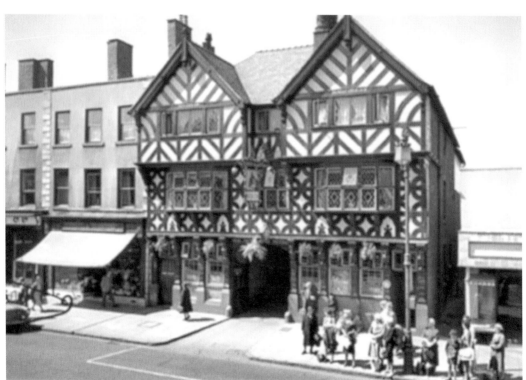

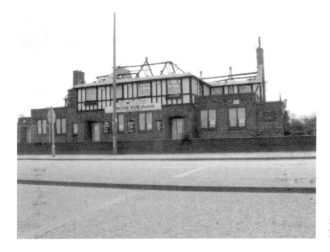

Demolition of the Twenty Row Public House in Leasowe Road.

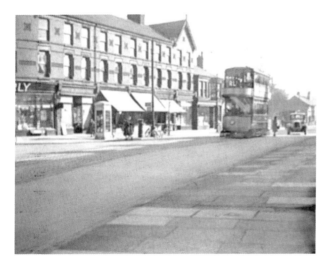

Rake Lane in the 1930s.

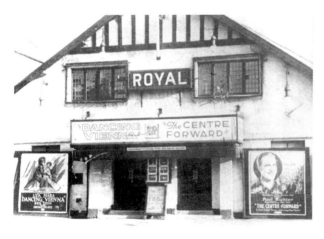

Royal Cinema, King Street, in 1925.

Families head for church along Rake Lane.

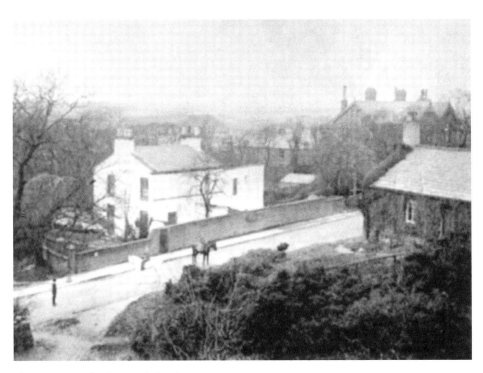

The Grammar School in Breck Road

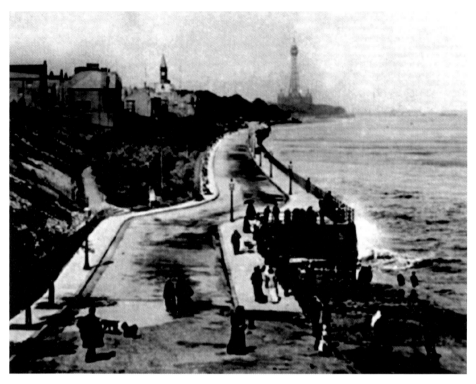

Above and below: Two views of Egremont Ferry and Promenade.

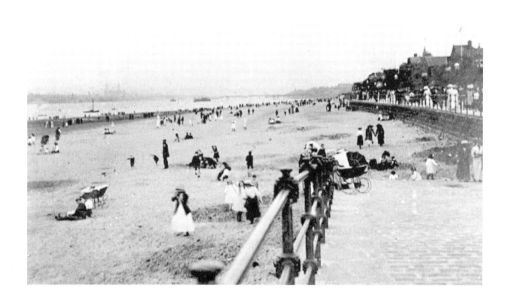

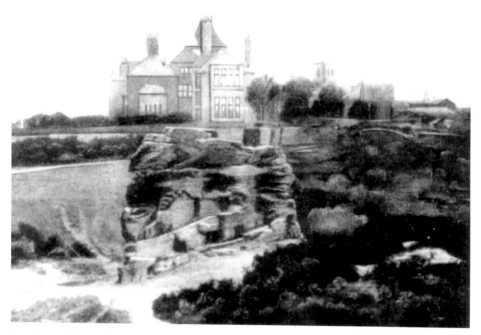

Land around the Breck was left open for quarrying stone, and the stone used in the construction of Leasowe Road came from this source.

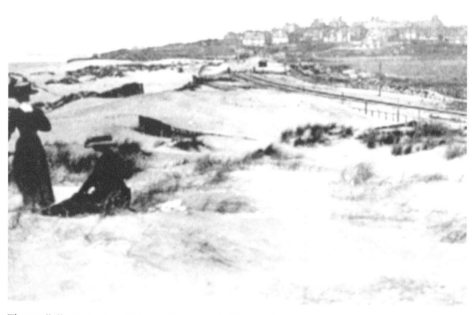

The sandhills at Harrison Drive looking towards New Brighton.

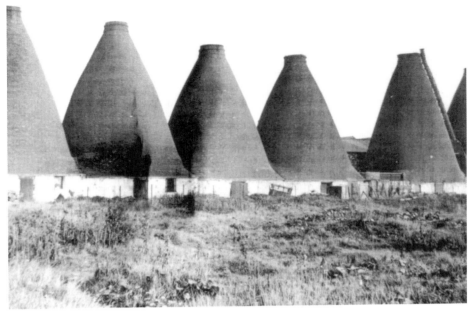

The six kilns of Seacombe Pottery, which were claimed to be the best equipped pottery works in the country. The works produced earthenware and stoneware, and the colour-printed ware was mainly of a blue or purplish tint. It was founded by John Goodwin of Staffordshire, who died in 1857, when the business was taken over by Thomas Orton of Wheatland Lane. The Pottery was closed in 1873, when a large consignment of uninsured goods were lost at sea on the way to the United States.

Wallasey village in the 1950s.

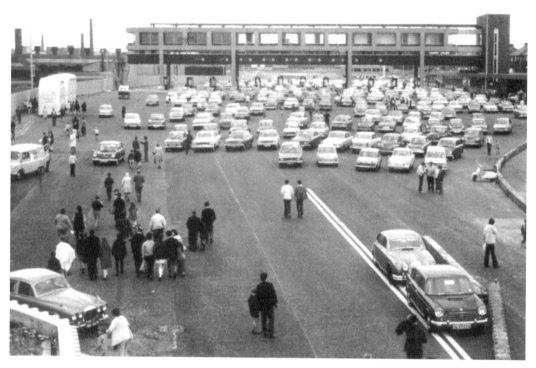

This page: The Kingsway Tunnel was open to the public prior to its opening in 1971.

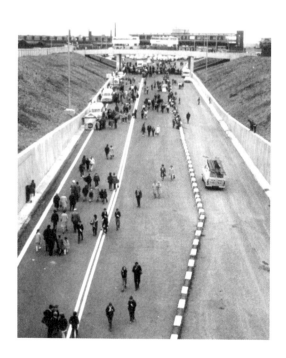

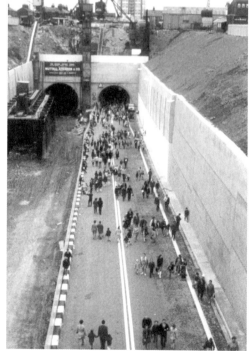

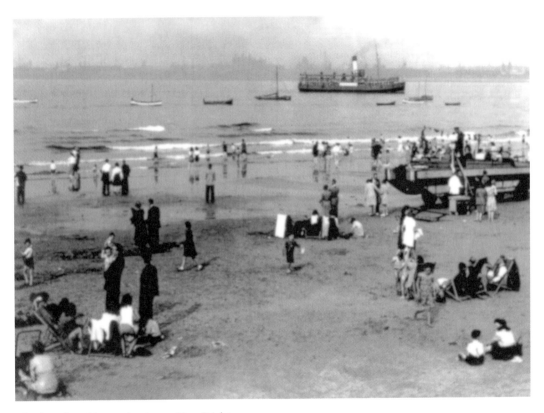

The ferry from Liverpool arrives at New Brighton.

CHAPTER 2

THE FERRIES

There are records showing a ferry crossing from Liverpool to Wallasey Pool that date back to 1552, when John Minshull, Lord of the Manor of Tranmere, operated the service. In 1626 there were ferry houses at Eastham, Woodside and Seacombe for passengers to shelter while they waited for the boat. One of the earliest references to a ferry across the Mersey to Wallasey was in an 1819 newspaper article about the sailboat ferry from Liverpool to the magazine. The *Hero* and *Paul Pry* are also recorded as calling at the magazines on their service from Hoylake to Liverpool, and the *Sir John Moore*, a wooden vessel built in Dumbarton in 1826.

The ferry at New Brighton was founded by James Atherton and his son-in-law, William Rowson, in 1830. There had been a ferry service operating from Egremont, by but 1834 passengers complained that the vessels were being used a tug boats and because of this the service was unreliable. In 1835 the Egremont Steam Ferry Company was formed to run an improved ferry, and introduce steam-powered vessels on the route. The Egremont and New Brighton ferries were purchased by Edward W. Coulbourn in 1850 and were transferred to the Wallasey Local Government Board in 1861, which designed and built a new pier at New Brighton, opened in 1866.

In 1863 William Carson, the Ferry Manager, designed the *Heather Bell*, which was the first ferry with two funnels. It had cabins below and saloons on deck and was employed on the New Brighton to Liverpool service for fourteen years, joining the *Mayflower*, *Water Lily* and *Wild Rose* which were introduced into service the previous year. *Heather Bell* was a double-ended flush-decked paddle steamer which was built by Thomas Vernon & Sons. She has a seven-foot high cabin below deck, and a seventy-foot long cabin amidships on deck with a promenade above. She had an official capacity of 807 passengers and the hull was divided into seven watertight compartments.

Sailing boats were used at Seacombe in 1821, and these were replaced by steam vessels two years later. The ferries appear to have been used for those who were connected with the ships that were anchored off the Wirral coast. By 1840 a floating landing stage was installed at Seacombe, and the ferry was connected to the Seacombe Hotel. In 1856 the ferry fleet consisted of the paddle-boats *Tiger*, *Elizabeth*, *Wallasey*, *Thomas Wilson*, *Fairy*, *James Atherton* and *Queen of Beauty*.

The annual passenger traffic had reached nearly two million by 1876, and it was decided that a larger ferry terminal was required at Seacombe. *Daisy* and *Sunflower* were delivered in 1879 and

The Egremont ferry in 1860. It was built in 1828 by Captain Askew and the stage was lengthened by William Carson in 1874-76.

Primrose in 1880. They were twin-funnelled vessels which were designed to carry 950 passengers. A new twin-screw vessel *Wallasey* was delivered in 1881 and *Violet* entered service two years later. The sister-ships *Crocus* and *Snowdrop* were introduced in 1884 and 1885 and *Woodchurch* had been purchased from Birkenhead Corporation and renamed *Shamrock*. The paddle-steamer *Thistle* came into service in 1891, followed by *John Herron* and *Pansy* in 1896. The coaling barge *Emily* and dredger *Tulip* were introduced with Rose in 1900 and *Lily* the following year, *Seacombe* in 1901 and *Iris* and *Daffodil* in 1906. *Bluebell*, later renamed *John Joyce* came into service with *Snowdrop* 1910.

During the First World War, on the 23 April 1918, the Royal Navy was attempting to blockade the Bruges Canal at its entrance into Zeebrugge to prevent German submarines using it as a base. It was decided to sink three cruisers which would have to pass the batteries on the Mole which first had to be destroyed. The cruiser *Vindictive* and the Wallasey ferry boats *Iris* and *Daffodil* were chosen to carry the troops for this attack. The ferries were chosen because of their light draught. On arrival, the *Vindictive*'s anchors failed to hold, but *Daffodil* managed to pin her against the Mole, enabling her gangways to be lowered to allow the landing party to storm the battery.

The *Daffodil* remained in place next to *Vindictive* for over an hour as the *Iris* was attempting to land her troops but as the scaling ladders failed to hold she moved next to the warship. On arrival they were ordered to leave and the *Iris* was soon under fire from the shore batteries and was receiving direct hits to the bridge hull. However, the naval launch *ML 558* placed herself between the battery and the ship and *Iris* was able to escape. *Daffodil* also received direct hits which caused her to flood and she was towed back to Dover by the *Trident*.

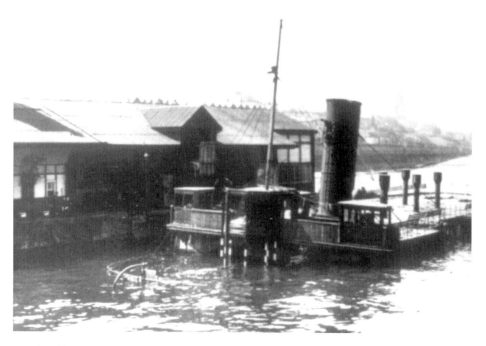

Royal Daffodil II was sunk at Seacombe Ferry Terminal.

The following month Wallasey Corporation resolved to petition King George V for permission to add 'Royal' to the names of the two ferries, and on the 30 May it was announced that, 'His Majesty had been graciously pleased to accede to the prayer thereof and to command that that the ferry steamships *Daffodil* and *Iris* which took part in the attack on Zeebrugge, should be renamed *Royal Daffodil* and *Royal Iris*'.

Leasowe and *Liscard* joined the ferry fleet in 1921, J. Farley and Francis Storey the following year. *Royal Iris* operated a programme of cruises in 1923, and her hull was painted grey. *Perch Rock* was introduced in 1929, and when the *Royal Iris* was sold in 1931, the *Royal Daffodil* took over as cruise ship until she was sold in 1933, and a new *Royal Daffodil* was launched. *Royal Daffodil II* was employed ferry duties, and also acted as a tender to troopships anchored in the river. On the night of the 8 May 1941 she was hit by a German bomb and sank at Seacombe Landing Stage. She was salvaged and re-entered service on the 2 June 1943. *J. Farley* and *Francis Storey* were taken over by the Admiralty and engaged in torped-net laying duties.

The new pier at Seacombe had been opened on 5 January 1880, and a floating roadway was added in 1925 so that vehicles could be transported across the river. A new pier was installed at Egremont in 1875 which was improved and rebuilt in 1909 and again in 1929. However, in May 1932 a tanker, the *British Commander*, dragged her anchor and collided with the pier. Repairs were carried out and the ferry service resumed again the following year. The pier was damaged again in May 1941 by the coaster *Newlands*. It was decided that the damage was so extensive and that the service from Egremont would end. The stage was broken up at Tranmere and the other sections of the pier were dismantled at the end of the Second World War.

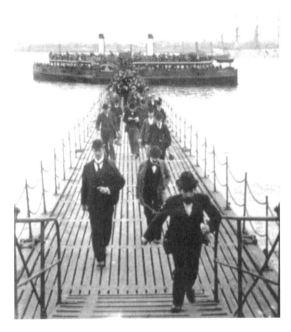

Passengers from Liverpool embark from the ferry at Egremont.

As the stage at New Brighton was in a very exposed position, it was damaged by the weather on numerous occasions. It was damaged by the Lamport & Holt vessel *Galileo* in 1865 and by a severe gale on 17 March 1907 when the two bridges fell into the water. The stage was renewed in 1921 and enlarged in 1928. A new passenger bridge was installed in the winter of 1934-5, enabling the entrance and turnstiles to be redesigned and rebuilt. The New Brighton ferry became a seasonal summer service in 1936, and the following year electrification of the railway line to New Brighton was completed.

After the war, Liscard was sold in 1946 and Leasowe in 1948 and the fleet consisted of *J. Farley, Francis Storey, Wallasey, Marlowe, Perch Rock, Royal Iris II* and *Royal Daffodil II*. The *Francis Storey* was sold in 1951, *J. Farley* in 1952, *Perch Rock* in 1953, *Marlowe* in 1958 and *Wallasey* in 1964. *Royal Iris* had her suffix 'II' dropped in 1947, was renamed *St. Hilary* in 1950 and sold in 1956. *Royal Daffodil II* was also renamed *St Hilary* in 1957 and was sold in 1962. *Channel Bell* was purchased in 1949 and renamed *Wallasey Belle*. She was sold in 1953.

Royal Iris was introduced in 1951, *Leasowe* in 1951, *Egremont* in 1952 and *Royal Daffodil II* in 1958. *Leasowe* survived until 1974 when she was sold, *Egremont* was towed to Salcombe, Devon, in 1976; *Royal Daffodil* (the suffix II was dropped in 1967) was sold in 1977 and *Royal Iris* in 1994.

Following the end of Second World War the passenger numbers on the ferry service to New Brighton gradually declined, as people were becoming more affluent and were able to buy cars, travel further on days out and take more expensive holidays. The pier at New Brighton also suffered from heavy silting, making it difficult for the ferries to operate at times. It was decided that the service should end, and the last ferry service operated on 26 September 1971. The pier

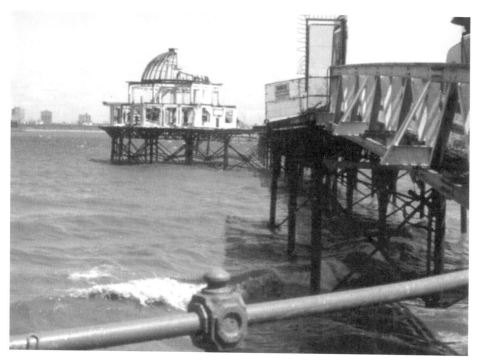

Demolition of New Brighton Ferry and Pier in 1978.

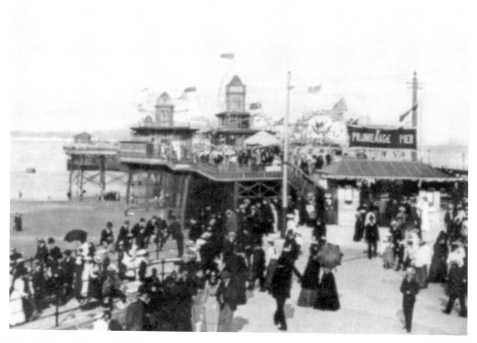

New Brighton Promenade Pier.

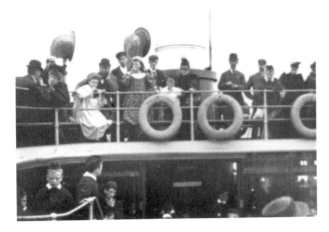

Passengers enjoy the sea air on the deck of the New Brighton ferry.

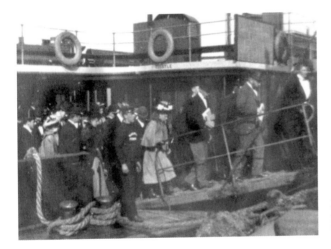

Passengers embark at New Brighton from the Wallasey Corporation ferry *Thistle*.

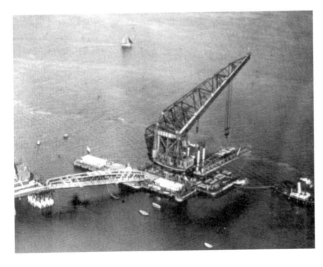

Replacing the New Brighton ferry bridge by the Mersey Docks & Harbour Board floating crane *Mammoth* on 29 September 1959.

was demolished in 1978. However, in 2008 it was announced that discussions are taking place to re-introduce a ferry service to New Brighton, and a feasibility study on the building of a new pier has been approved.

The New Brighton Promenade Pier was built in 1867 next to the ferry pier. It was opened on 7 September that year and completed the following April. The pier was 550 feet long and 70 feet wide, and its entrance was through the turnstiles on the ferry pier. The pierrots, Aldeler & Sutton took their show from the beach to the pavilion on the pier. There were smoking rooms and rest rooms and a new pavilion was built in 1913. It was closed for four years between 1923 and 1927, when it was purchased by Wallasey Corporation which built a new entrance from the promenade. The pier was rebuilt and refurbished at a cost of £45,000 in 1931.

The Pavilion Theatre, opened in 1892, was 130 feet in length. It was used for concerts, bazaars, flower shows and became a popular entertainment complex on the pier It was refurbished in 1908 and reopened on 15 March the following year. As the improvements included the installation of central heating, the Theatre could then be used in the winter months for showing films, a season of plays and a pantomime. With the increasing popularity of the resort the number of cinemas and theatres increased and the Pavilion Theatre finally closed in 1923 as it could not compete with the newer establishments and different forms of entertainment

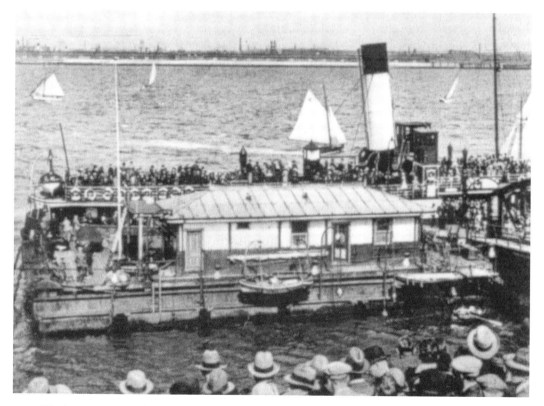

The ferry prepares to depart from New Brighton to Liverpool.

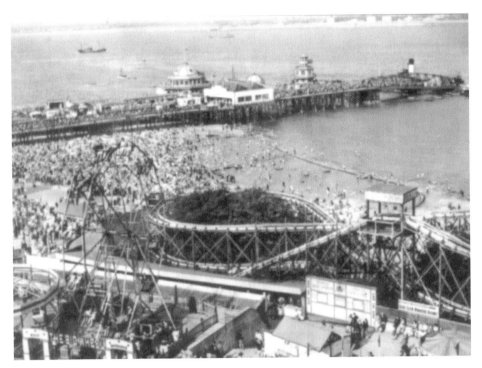

Visitors take advantage of the weather at New Brighton on 25 August 1947.

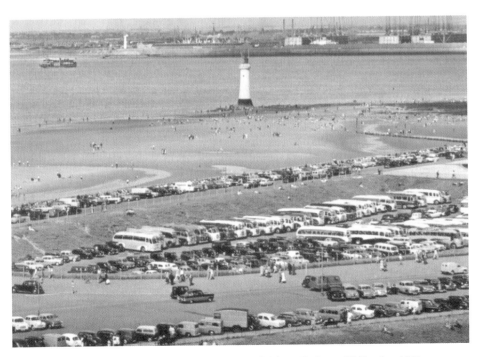

Coaches and private cars fill the car park next to New Brighton Baths on 10 October 1961.

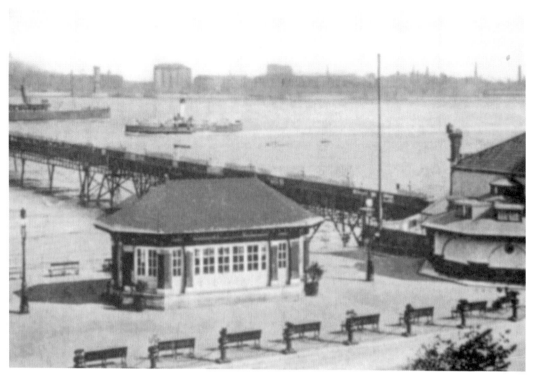

Above and below: Ships passing Egremont Ferry.

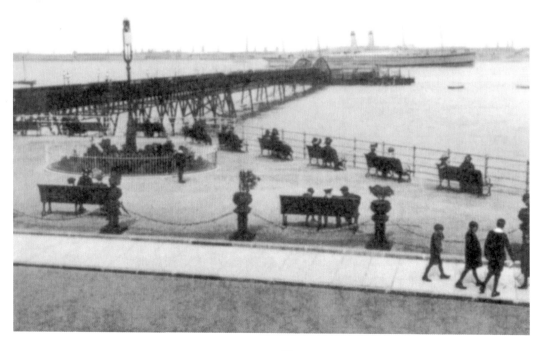

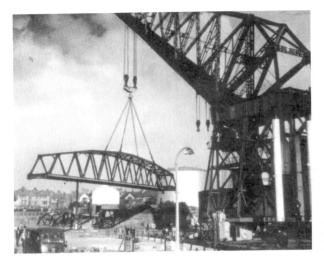

A replacement ferry bridge is loaded onto the floating crane in Wallasey Docks.

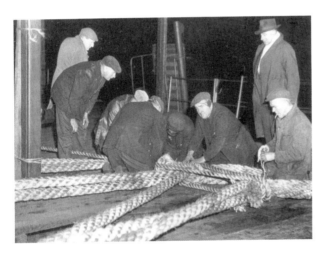

The New Brighton landing stage is made secure by a gang of workers after a storm in September 1957.

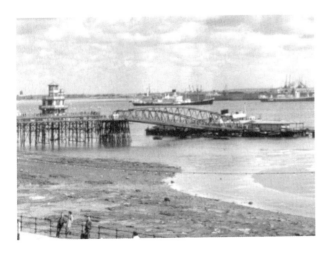

A Blue Funnel cargo ship passes an Ellerman vessel off New Brighton Ferry Stage.

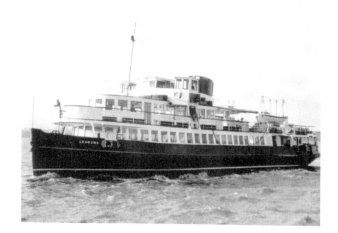

The Wallasey Corporation ferry
Leasowe on service in the River
Mersey.

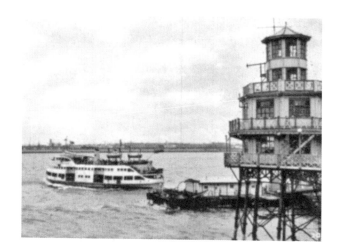

The Wallasey Corporation ferry
Royal Iris leaving New Brighton for
Liverpool.

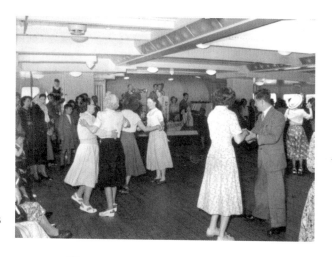

A dance cruise on the *Royal Iris* on 13
November 1951.

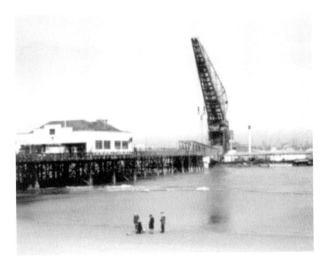

A new bridge is installed at New Brighton in 1962 by the floating crane *Mammoth*.

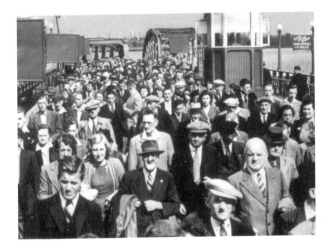

Passengers disembarking from the New Brighton ferry.

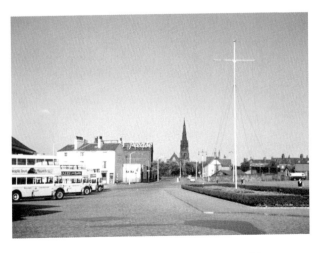

The approach to Seacombe Ferry Terminal in the 1960s.

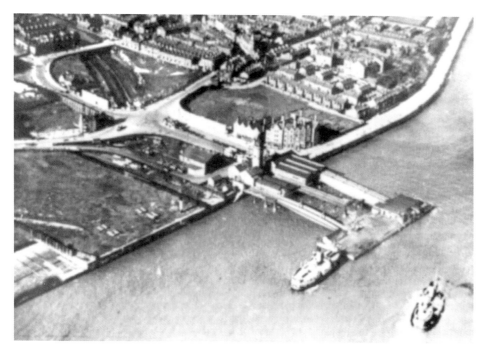

Seacombe Railway Station and Ferry in 1940.

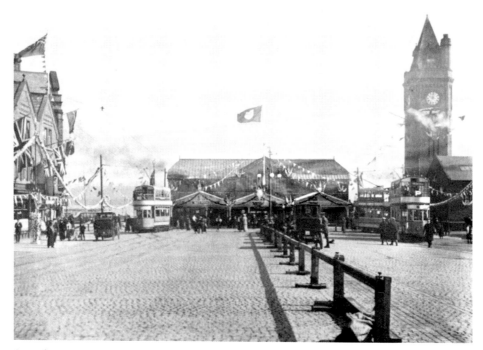

A royal visit to Seacombe Ferry terminal, 1914.

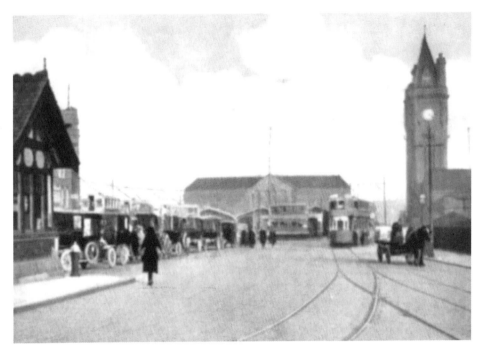

Taxis and trams await passengers at Seacombe Ferry.

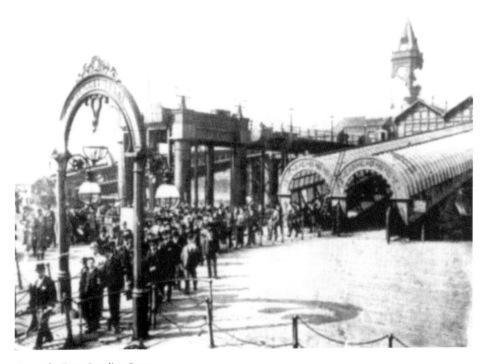

Seacombe Ferry Landing Stage.

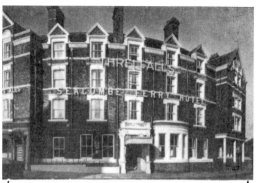

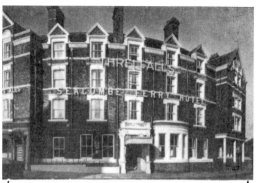

★
SEACOMBE FERRY HOTEL

A.A. **WALLASEY** R.A.C.

Fully Licensed

On River Front, Opposite to Ferry
Liverpool within 10 minutes

25 BEDROOMS, ALL WITH H. & C.
Lift to all Floors
Central Heating and Electric Fires throughout
Cocktail Bar open for Residents and Dining Room Patrons
RENOWNED FOR ITS CUISINE

TARIFF ON APPLICATION Tel. : Wallasey **142**

Right: Seacombe Ferry Hotel advertisment.

Below: Seacombe Ferry Hotel.

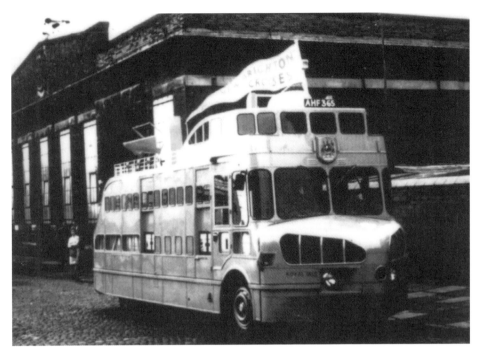

A Wallasey Corporation bus was modelled on the ferry *Royal Iris* and used to advertise the ferry and dance cruise programme.

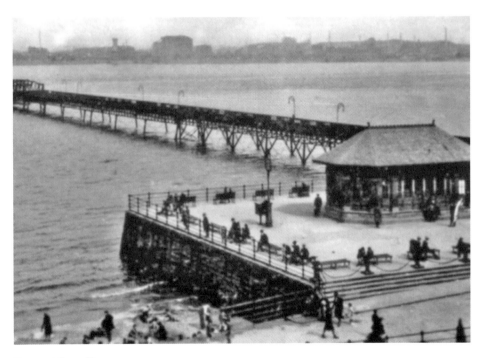

Egremont Ferry Pier.

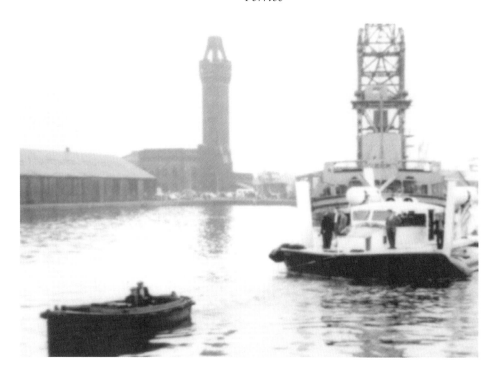

This page: The hovercraft began operating between Moreton and Rhyl, North Wales, on 20 July 1962. It was a Vickers Type VA3 hovercraft and was the first mail and passenger hovercraft service in the world. It weighed about ten tons and had a top speed of sixty knots. The service was operated by British United Airways, with Furness Withy as the local shipping agent. It was planned to operate twelve trips a day but this was only achieved on six days.

It was scheduled to operate for fifty-four days, but only ran for nineteen of these because of strong winds, high seas and the failure of the rear lift engine. It operated its last trip from Moreton to Rhyl on 14 September 1962, when one of its engines failed followed by the other lift engine. It eventually managed to get into Rhyl. The hovercraft was due to sail for two further days, but the day after the engine failure the conditions were too rough and the captain remained on board overnight.

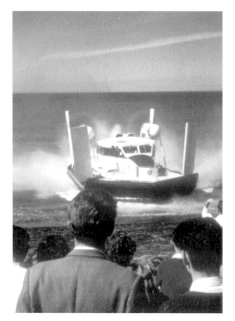

However, the craft broke from its mooring in the early hours of the morning and the captain managed to start the engine. The high seas and strong winds caused the craft to break from its moorings again the following day. The lifeboat was called and the crew abandoned the craft. When the tide eventually drove the craft back to the sea wall, the crew were able to make it secure. The hovercraft continued to be damaged by the high seas and it was lifted out of the water by two mobile cranes on 17 September; the experimental service was terminated.

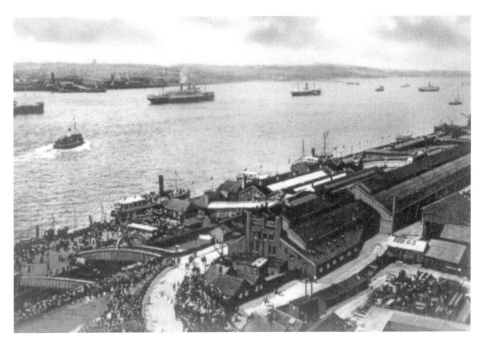

A New Brighton ferry weaves between cargo and passenger liners off Princes Landing Stage, Liverpool.

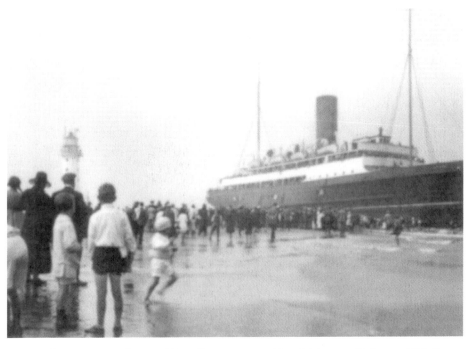

The Isle of Man Steam Packet vessel *King Orry* aground at New Brighton on 19 August 1921. She was re-floated the following day.

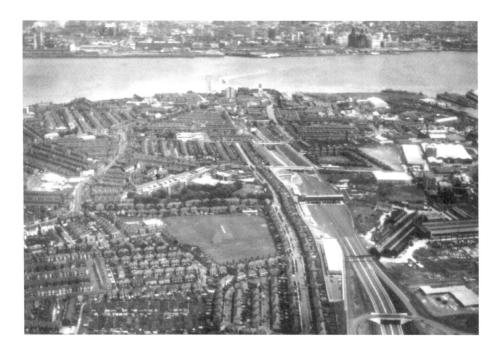

The entrance to the Mersey Tunnel with a ferry approaching Seacombe from Liverpool.

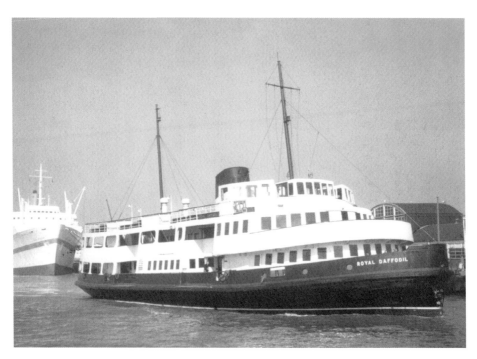

The Wallasey Corporation ferry *Royal Daffodil* approaching Liverpool Pier Head on the Seacombe service in 1969.

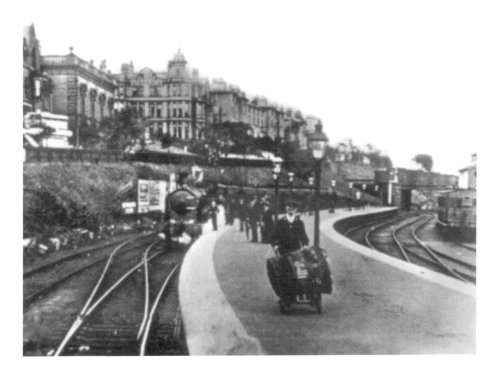

New Brighton Station.

CHAPTER 3

MERSEY RAILWAYS

In 1825 Sir Marc Isambard Brunel suggested the possibility of building a tunnel to connect the Wirral with Liverpool for road traffic. In the middle of the nineteenth century Sir John Hawkshaw pioneered a scheme known as the North Wales Railway, which would start in Liverpool and go under the River Mersey, cross the Wirral and go over the Dee by viaduct at Flint. The Mersey Pneumatic Railway was proposed in 1866, based on the successful Post Office Railway in London where mail was propelled along by compressed air.

In 1871 parliamentary authority was obtained for the construction of a double-track railway, but it took nine further years for funds to be obtained to start the project. When the initial contractor got into financial difficulties, the job was given to Major Samuel Isaac, who had made his fortune from work during the Crimean War. The boring machine used was devised by Colonel Beaumont of the Royal Engineers, and explosives and picks and shovels were used for the building of the main tunnel.

The line from James Street in Liverpool to Hamilton Square and Green Lane in Birkenhead was opened by the Prince of Wales in 1886. The track was extended to Birkenhead Park, West Kirby, to New Brighton in 1888 and Rock Ferry in 1891. The following year an underground station was opened at Central Station in Liverpool. The trains were propelled by steam engines initially, with the steam and smoke polluting the underground stations. The railway was on the verge of bankruptcy due to the low patronage caused by the choking atmosphere created by the steam engines. In 1903 the Mersey Railway was electrified and became the world's first electric railway.

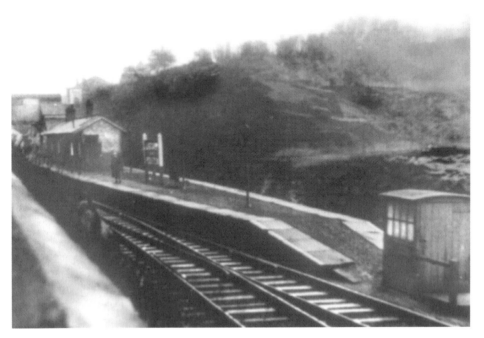

Liscard and Poulton Station, which was closed for passenger traffic on 3 January 1960.

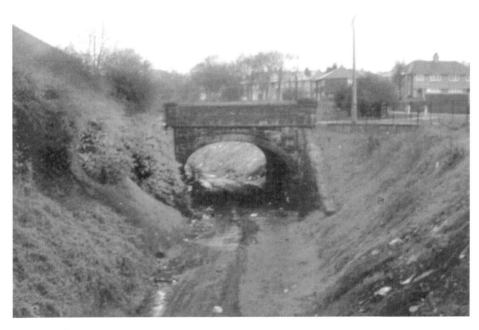

Poulton Railway cutting.

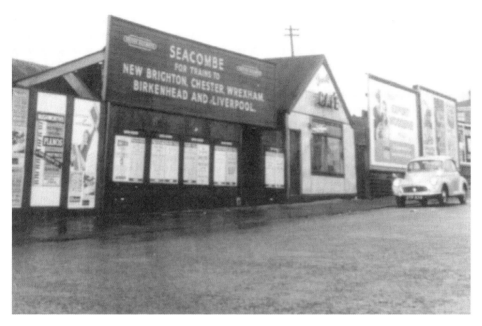

Seacombe Railway Station advertising services to New Brighton, Chester, Wrexham, Birkenhead and Liverpool.

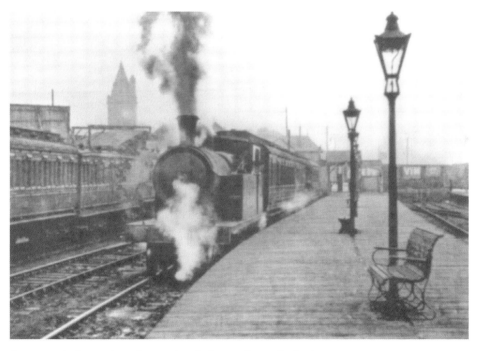

A steam train departs from the wooden platform at Seacombe Station.

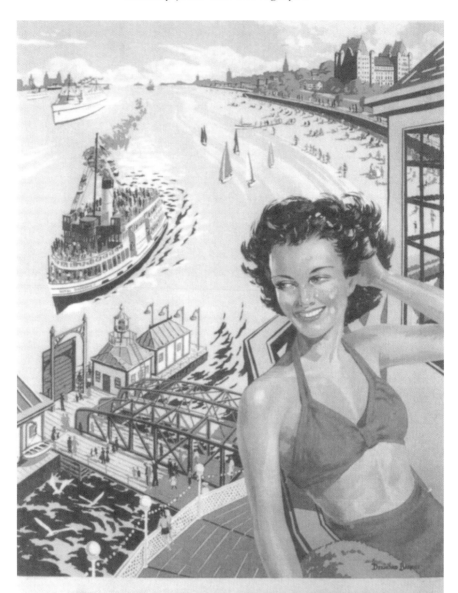

British Rail advertisement for New Brighton.

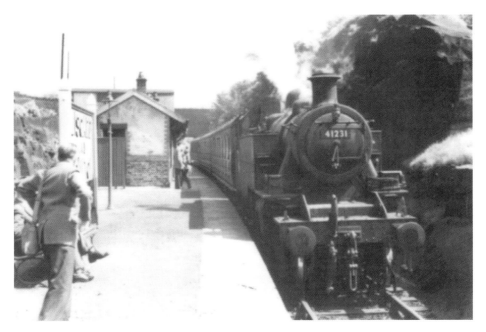

Passengers prepare to alight onto a steam train at Liscard and Poulton Station.

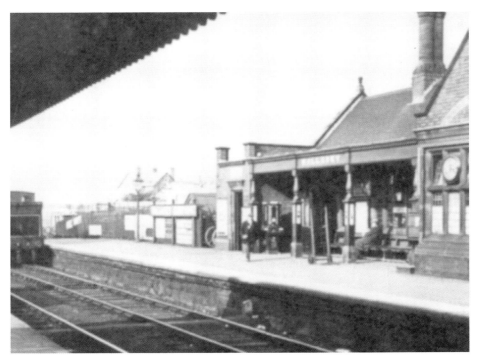

Grove Road Station in 1910.

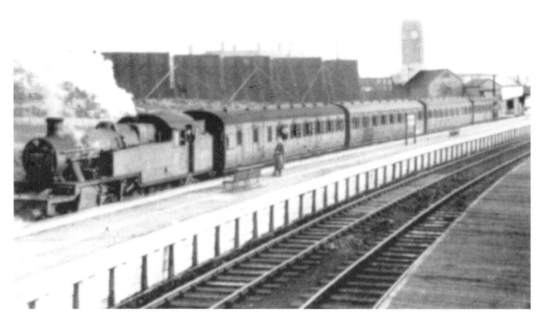

Above and below: Views of Seacombe Station.

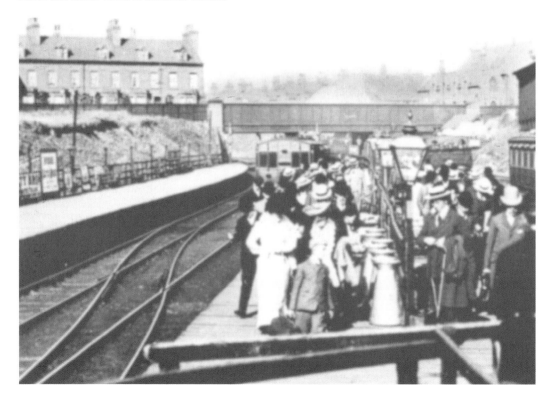

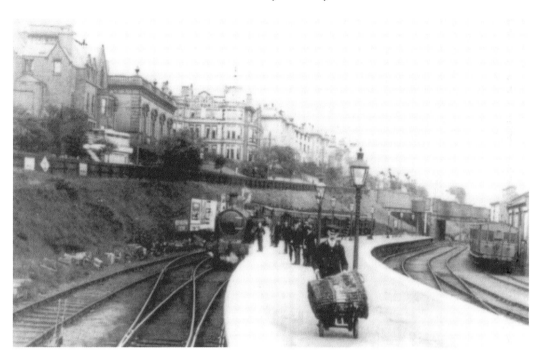

A porter uses his trolley to bring passengers luggage from a steam train at New Brighton Station.

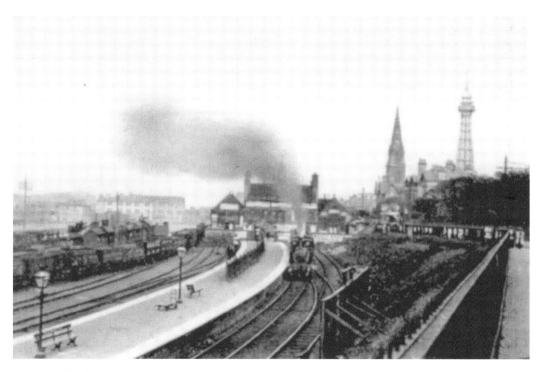

New Brighton Station and Tower.

Warren Station on the New Brighton line was closed on 1 October 1915.

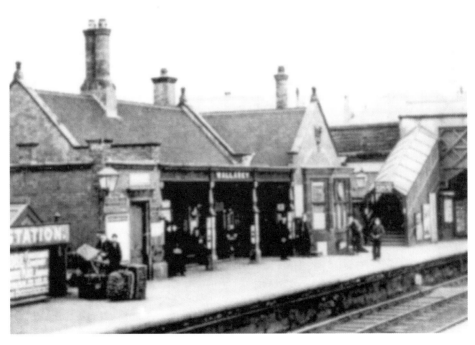

Grove Road Station.

Chapter 4

NEW BRIGHTON

In 1830 James Atherton, a merchant of Liverpool, purchased land at Rock Point to develop as a desirable residential and watering-place for the gentry. The land enjoyed views out to sea across the River Mersey, above a good beach at the north-west angle of Wallasey. It was to be the equal of most elegant seaside resort built in the Regency period, and was duly named New Brighton. Atherton was described by Sir James Picton as 'ardent, bold and daring in character, while everything he undertook was carried out on a scale of magnificence'.

Prior to this development the area consisted mainly of sandhills, grassy moorland and a few fishermen's cottages. Villas were built in spacious grounds, each with an uninterrupted view of the sea, the Welsh Mountains or the Lancashire coastline. Atherton's prospectus emphasised the advantages of the development: the beautiful beach, clean sands and the interesting sea view – more than any other resort could boast. The proximity to Liverpool, together with the certainty and safety of steam navigation made it a most agreeable and desirable place to the nobility and gentry of all the neighbouring counties.

The foundation stone of St James' Church was laid on 16 February 1854, but it took over two years to be completed after damage in the great storm on 29 November 1854. In 1861 the population increased to 2,404; in 1871 to 3,319 and in 1881 to 4,910. Many of the large houses were later converted to inexpensive hotels and boarding houses for the visitors coming to the resort from the Lancashire industrial towns.

Victoria Road became the central thoroughfare, with shops, eating-houses and entertainment establishments. A promenade was built along the shore, known as the 'Ham & Egg Parade' and 'Aquarium Parade', with its own eating-houses and refreshment rooms, which became very popular with the holidaymakers and visitors. The pier was completed in 1868; the palace and pavilion were erected in 1880, and the tower and grounds were completed in 1900.

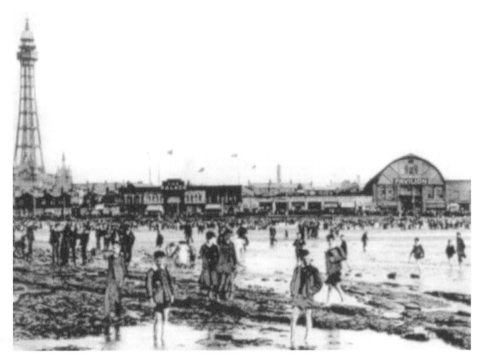

The Tower, Ham & Egg Parade and Pavilion at New Brighton.

The Ham & Egg Parade.

ADDITIONAL ENTERTAINMENTS

MONDAY, 21st JULY (High Tide 3-24 p.m.)

DANCE CRUISE ON "ROYAL IRIS" ... 3-0 from New Brighton.

TUESDAY, 22nd JULY (High Tide 4-12 p.m.)

DAILY EXPRESS—
"IRIS, THE WEATHER GIRL" ... Central Prom. 10 to 12-30.
WALLASEY POLICE ANNUAL RIVER
SWIM & CRUISE Dive-in from "Royal Iris" 7-35.
DANCING Grosvenor Ballroom 8-0.
DANCE CRUISE ON "ROYAL IRIS" ... 3-0 from New Brighton.

WEDNESDAY, 23rd JULY (High Tide 5-05 p.m.)

5th Heats—"MISS NEW BRIGHTON" and
"STARLET" Contests; Heat 1—"WAL-
LASEY SUMMER GIRL" Contest, and
MAZDA "QUEEN OF LIGHT" Contest
Heat ... New Brighton Bathing Pool 3-0.
DANCE CRUISES ON "ROYAL IRIS" ... 1-0, 3-0 & 7-30 from New Brighton.

THURSDAY, 24th JULY (High Tide 6-06 p.m.)

"MELODY INN" REVUE, No. 4 Programme Floral Pavilion 6-30 & 8-40.
DANCING Grosvenor Ballroom 8-0.
DANCE CRUISES ON "ROYAL IRIS" ... 1-0, 3-0 & 7-30 from New Brighton.

FRIDAY, 25th JULY (High Tide 7-19 p.m.)

DANCING Grosvenor Ballroom 8-0.
DANCE CRUISE ON "ROYAL IRIS" ... 3-0 from New Brighton.

SATURDAY, 26th JULY (High Tide 8-35 p.m.)

CRICKET—Wallasey v. Liverpool ... The Oval 2-30.
WRESTLING Tower Theatre 7-30.
DANCING Riverside Ballroom, Grosvenor Ball-
room, Grand Hotel 8-0.
DANCE CRUISES ON "ROYAL IRIS" ... 1-0, 3-0 & 7-0 from New Brighton.
(9-30 from Liverpool only).

11 Cinemas — 2 Zoos — Marine Lake & Lido — Gigantic Amusement Parks

TWO GREAT SHOWS YOU MUST NOT MISS !!

"MELODY INN" REVUE	"DANCING WATERS"
6-30 & 8-40 FLORAL PAVILION	TOWER THEATRE
3/6, 2/6, 1/6 (Children ½ as Sat.)	Performances throughout the day commencing 2-0 p.m.
YOU WILL NOT SEE A BETTER RESIDENT HOLIDAY SHOW IN ANY SEASIDE RESORT !	Adults 1/6 — Children 1/-
Lovely Girls — Beautiful Dresses Magnificent Scenes	A BREATHTAKING, MAGNIFICENT SPECTACLE YOU WILL REMEMBER IN YEARS TO COME !

Tidal Predictions for Liverpool (& New Brighton) are supplied by Liverpool Observatory
& Tidal Institute, copyright reserved.

Right: New Brighton entertainment programme in 1952.

Below: The Tower, Tivoli Theatre and beach at New Brighton on 16 May 1948.

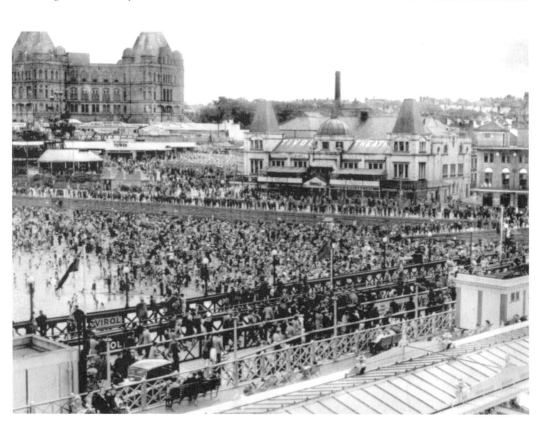

Left: New Brighton guide.

Below: The Tower Grounds and boating lake on
11 March 1939.

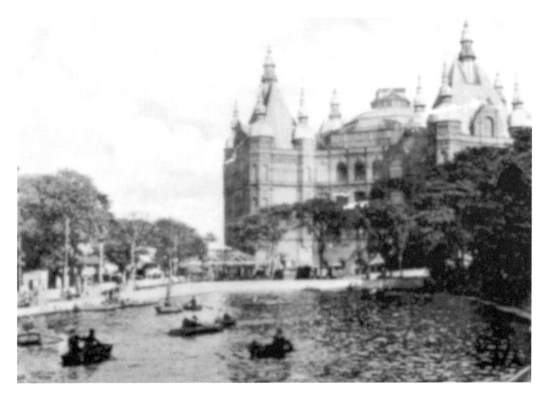

84

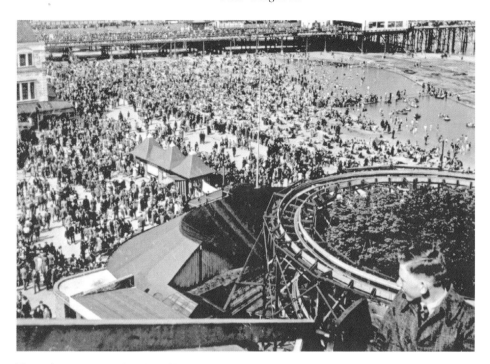

Tower Amusements on 22 May 1945.

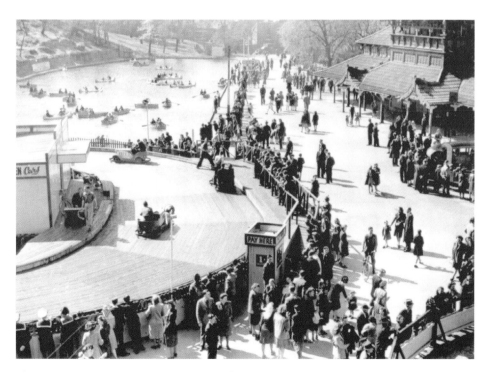

The racing circuit and lake at the Tower grounds on 20 April 1946.

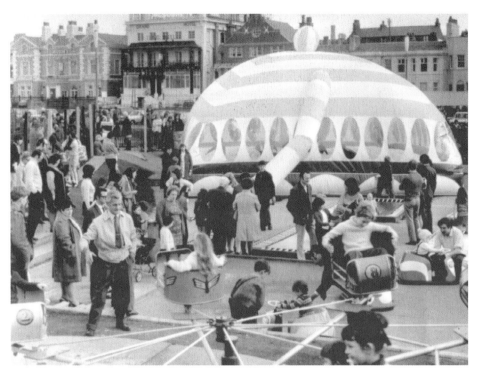

Above and below: Children enjoying the rides on Easter Sunday, 1972.

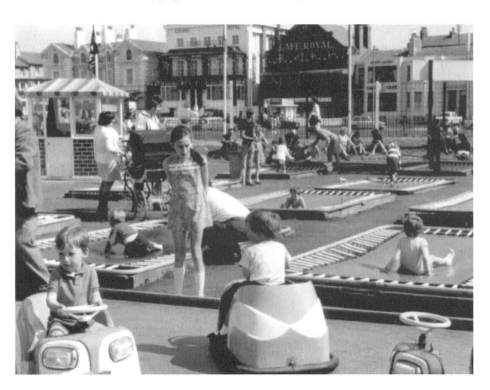

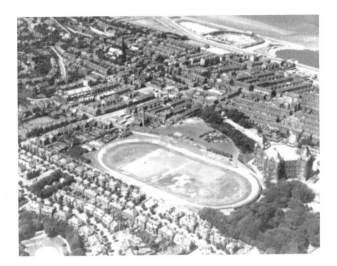

The Tower Grounds in 1946.

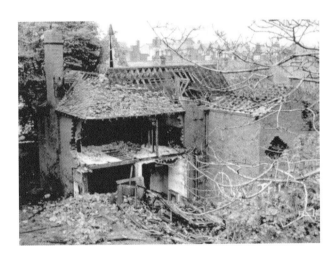

Tower Grounds Lodge being
demolished on 25 May 1972.

The Hotel Victoria in New Brighton.

Liscard Battery was built in 1858 near the Magazines. It was purchased by a builder in 1936, when houses were built on the site.

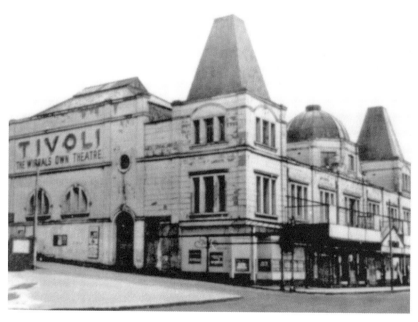

The Tivoli Theatre was opened in 1914 starring Lily Langtry It was sold to Pat Collins in 1923 who sold it to William Swire in 1925, and it was sold to Gaumont British Company in 1928. It operated for a short time as a cinema, and in 1937 it became the New Tivoli. It was closed in 1938 and reopened by Leam Productions Limited in 1945, who presented twice-nightly variety shows in the summer months and a repertory production in the winter until 1955. It then operated as an amusement arcade until a fire in 1976. The building was later demolished.

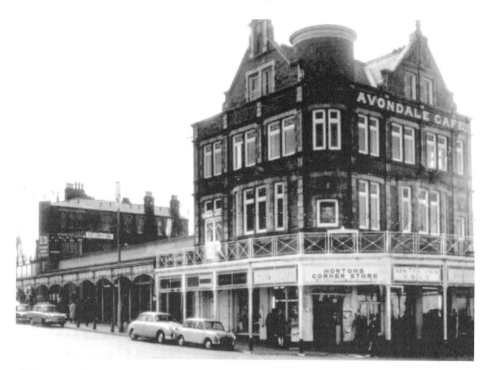

The bottom of Victoria Road in May 1969.

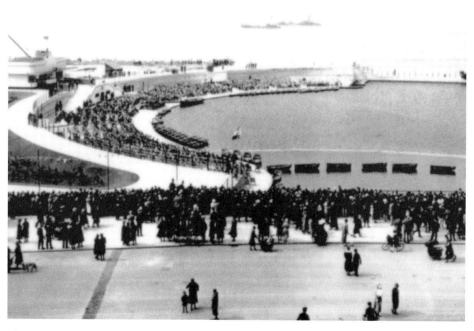

The Marine Lake at New Brighton.

Vale Park, New Brighton.

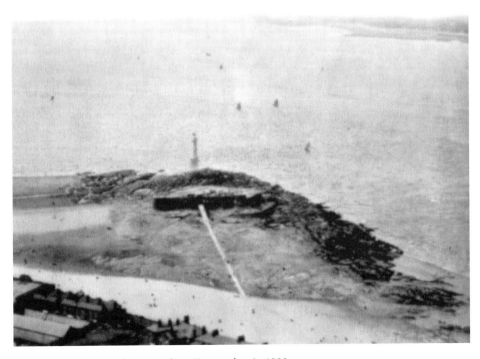

The view from the top of New Brighton Tower taken in 1900.

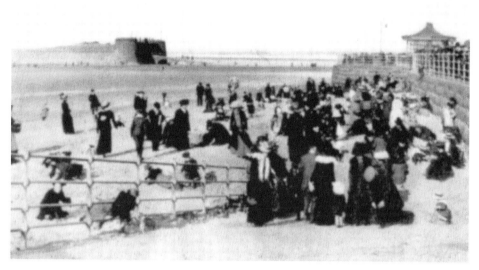

New Brighton beach in 1900.

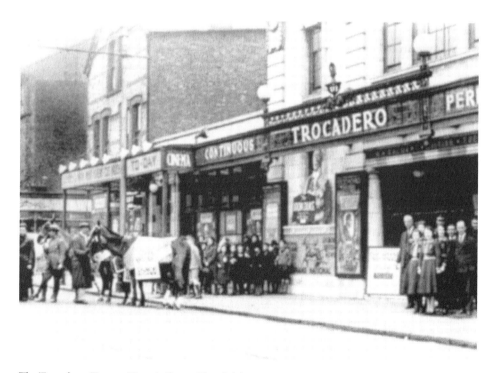

The Trocadero Cinema, Victoria Street, New Brighton.

Vale Park Grandstand.

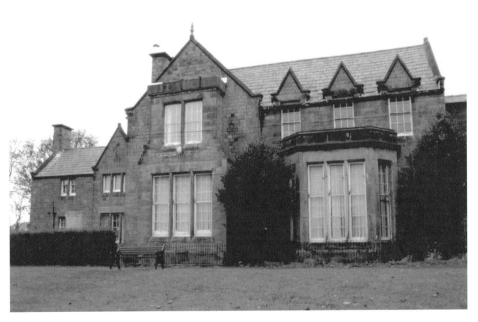

Earlston House was bought by Wallasey Corporation in 1898 and the Central Library opened there in 1902. Mr Andrew Carnegie provided £9,000 for the building of a new library in 1908, adjoining Earlston House, which was opened on 30 September 1911.

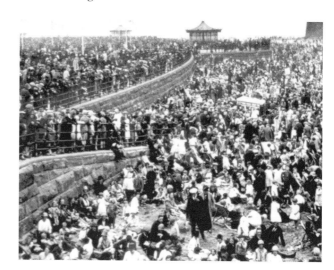

A busy weekend at New Brighton beach.

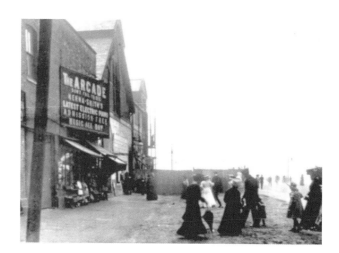

The Arcade, Old Palace and Pavilion Studio at New Brighton.

Frank Huck's waterplane, on New Brighton beach on 27 August 1912, which offered flights at £2 a trip. A special raft was moored on the beach to enable passengers to reach the aircraft. The trips were sponsored by the *Daily Mail* and New Brighton Pier Company.

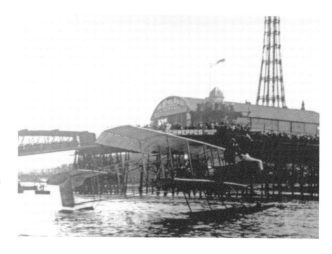

SUNDAY, 20th JULY (High Tide 2-41 p.m.)

BAND CONCERTS—
Besses o' th' Barn Band Vale Park 3-0 (F. Pav. if wet).
Floral Pavilion 7-0.
TED LOWE BAND SHOWS & TALENT
CONTESTS Promenade Pier 3-0 & 7-0.
"THE SUNDAY SHOW" Promenade Pier 3-0.
"DANCING WATERS" Tower Theatre throughout the day.
MOTOR BUS TOWN TOUR Prom. (opp. Pier) 2-30 & 6-30.
DANCE CRUISES ON "ROYAL IRIS" ... 1-0, 3-0 & 7-30 from New Brighton.

ENTERTAINMENTS AVAILABLE EACH WEEKDAY
(Monday to Saturday)

"MELODY INN" REVUE Flora! Pavilion 6-30 & 8-40.
"DANCING WATERS" Tower Theatre throughout the day.
"PIER FOLLIES" Holiday Variety Show ... Pier 2 to 5-15 (2-30 F. Pav. if wet).
TED LOWE BAND SHOW & DANCING ... Pier 3-0 (excepting Wednesday).
"JOYTIME" CHILDREN'S SHOW Vale Park 3-0 & 6-30.
MOTOR BUS TOWN TOUR Prom. (opp. Pier) 2-30 & 6-30.
(excepting Saturday).
DANCING Pier 7-30; Tower Ballroom 7-30.
DANCE CRUISES ON "ROYAL IRIS" ... As under (see announcements for
additional Cruises)

ADDITIONAL ENTERTAINMENTS

MONDAY, 21st JULY (High Tide 3-24 p.m.)
DANCE CRUISE ON "ROYAL IRIS" ... 3-0 from New Brighton.

Left: List of events taking place at New Brighton.

Below: The beach and promenade in front of the Tivoli Theatre.

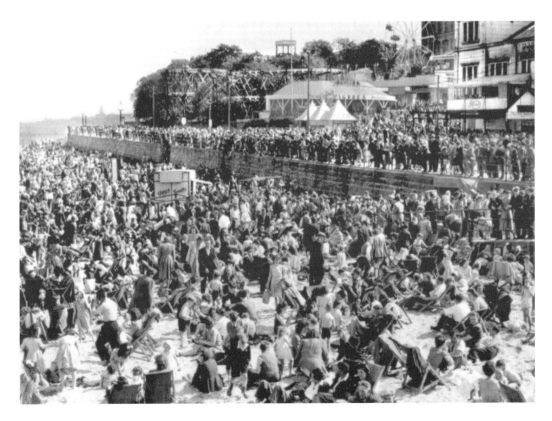

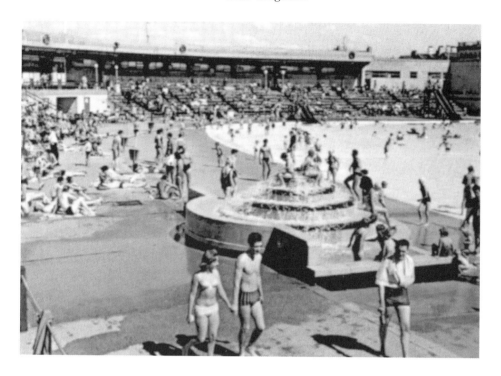

Above: New Brighton Swimming Pool.

Right: The Riverside Restaurant above New Brighton Swimming Pool.

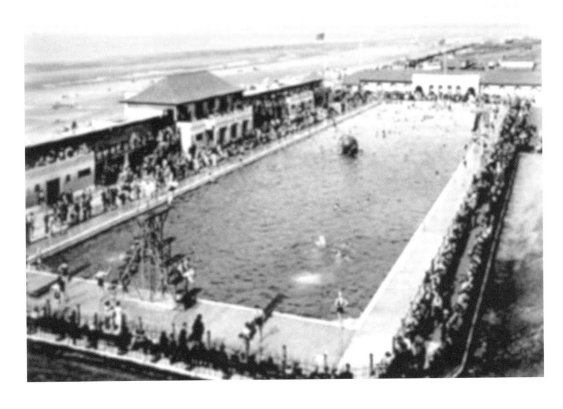

This page: Derby Swimming Pool.

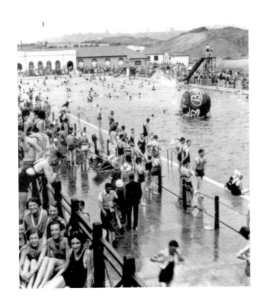

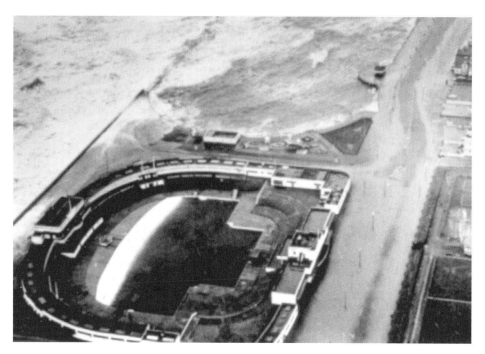

New Brighton Swimming Pool during the storm of 1990.

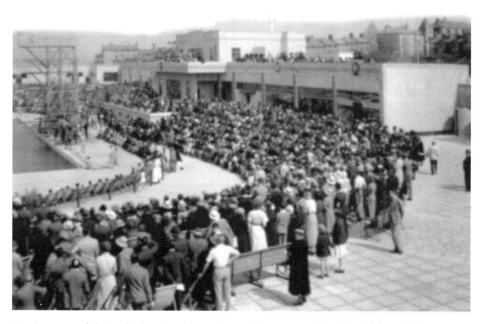

A swimming and diving display takes place in front of a large crowd at New Brighton Pool.

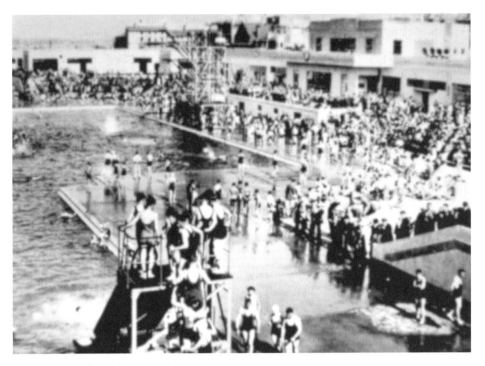

A hot summer's day at the swimming pool.

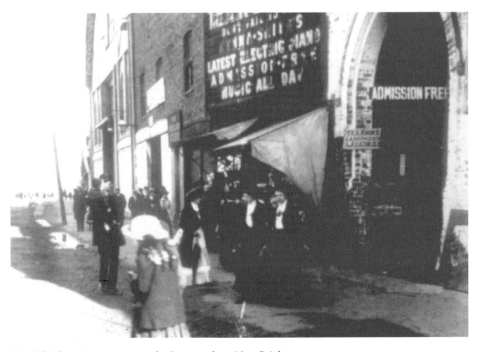

The old Palace Amusements on the Promenade at New Brighton.

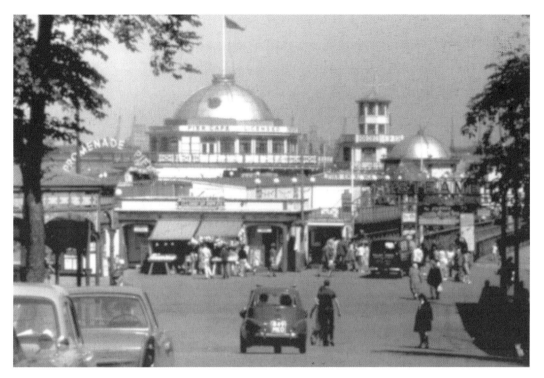

Above and below: Victoria Road and Pier Entrance at New Brighton.

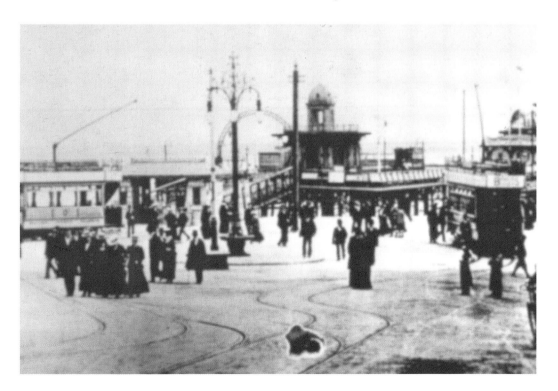

Above: The construction of Kings Parade in 1932.

Below: Newly opened Kings Parade in 1938.

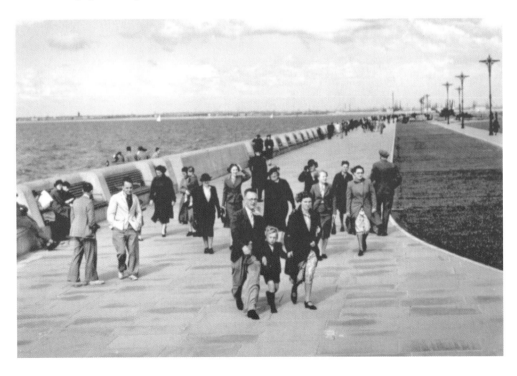

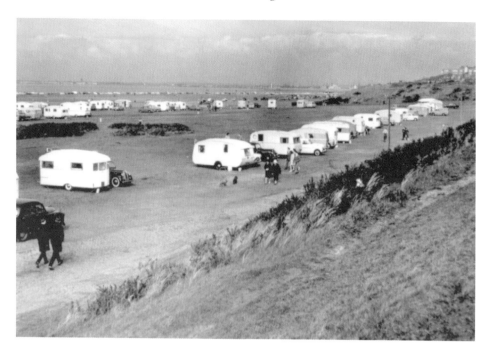

Above: Caravan Club meeting in the 'Dips' at New Brighton on 3 April 1961.

Below: F.F. Scott Family Butcher at 83 Victoria Street, New Brighton.

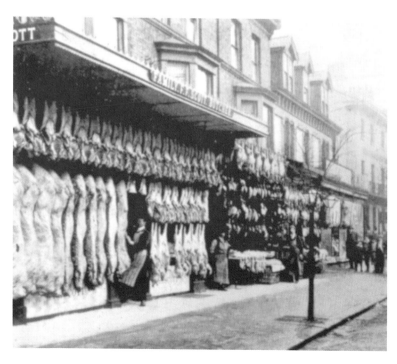

Victoria Street is prepared for a housing development to be built.

CHAPTER 5

FORT PERCH ROCK

In the seventeenth century it was also recognised that one of the main dangers to shipping entering the River Mersey was the Black Rock at the river mouth. A "perch" , a wooden pole set into the riverbed to warn mariners of the obstacle, was erected there in 1683. An Act of Parliament was passed in 1761 to enable lighthouses to be erected at Leasowe and Hoylake, and a light was erected on Bidston Hill in 1771.

The lighthouse was of similar design to the Eddystone Lighthouse at Plymouth. It was built of marble from Angelsey by Tomkinson & Co., and rises ninety feet above the rocks. It was designed so that each stone is interlocked with the next, and is coated with a volcanic substance from Mount Etna, which becomes rock hard when in contact with water. It was claimed that the revolving light was the first of its kind in this country, and the complete structure cost £27,500. The light is 77 feet above the rocks, and has a range of 14 miles. However, following the installation of a new radar system for the port, the light shone for the last time on 1 October 1973.

The guns at the fort have only been fired three times in anger. They were fired twice during the First World War, and once in the Second World War On each occasion a fishing boat had approached the river without official approval; the first shot ever fired actually landed on the sandhills at Hightown and the second struck the bow of a liner at anchor. In the Second World War the fort was camouflaged as a tea garden.

The fort was designed to hold 100 men, but it was normally staffed by only a handful. In the 1850s the Rock Channel began to silt up, and traffic entered the Mersey via the Crosby channel. Also, the building of iron-clad armoured ships meant that there was a need for more powerful guns. Consequently, in 1861 eight of the 32-ponders were removed and replaced with 68-ponders, and two seven-inch Armstrong breech loaders were fitted. The invalid soldiers who had staffed the fort were replaced by the New Brighton Company of Artillery who volunteered in 1859-60. The volunteer groups set up in this period were the forerunners of the Territorial Army and Home Guard.

The defences at the fort were replaced in 1893 by a pair of Maxim machine guns, and the Royal Engineers moved in the following year to carry out the remodelling of the seaward Towers and sea wall. This was to enable three Mark VI six-inch guns which were fitted by 1899. These were replaced in 1910 with Mark VII six-inch guns, which had a range of 20,200 yards. The gun positions were also raised. An observation post, searchlight and temporary huts were installed in 1919. The drawbridge was finally replaced by a solid causeway in 1930.

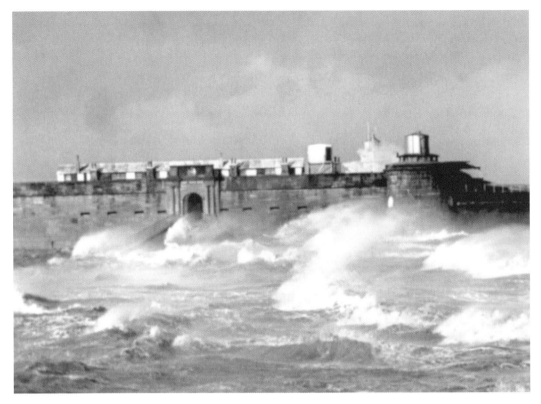

Fort Perch Rock on a stormy winter's day in November 1954.

The fort commander claimed that he fired the first shots of the Second World War when a fishing boat approached it, minutes after war had been declared. A shot was fired across its bows, shattering some windows in cafés and shops in New Brighton. The fort was painted green and disguised as a tea garden during the war, and a large 'Tea' sign was painted on the roof.

The guns were last fired in 1951 during the Festival of Britain, and were moved to the Woolwich Arsenal. The fort was sold to Thomas Mann and T. Kershaw for £4,000 in 1958. It was sold to R.P. Ashworth in 1969 and in 1976 to Norman Kingham, who attempted to restore the seaward side of the structure. The fort was sold again in 1997, with restoration, modification and improvement work continuing. It is open to the public most of the year and is also the venue for special events, exhibitions and concerts.

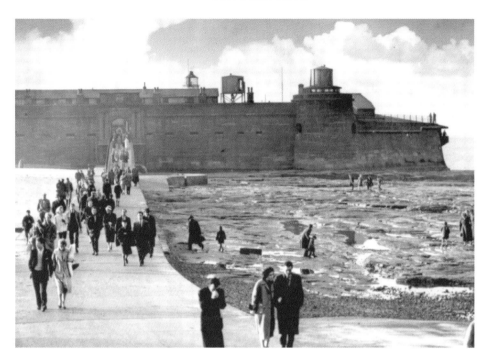

A Sunday afternoon walk around the Marine Lake.

Waves crash over the Fort on 21 March 1957.

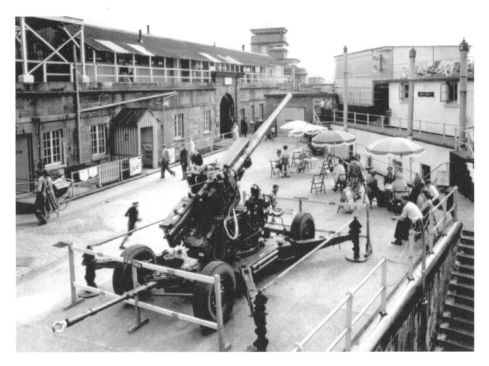

Above: A World War II gun exhibited in the Fort on 18 May 1959.

Below: A day excursion steamer sails down the Rock Channel past the Fort on its way to Llandudno, North Wales.

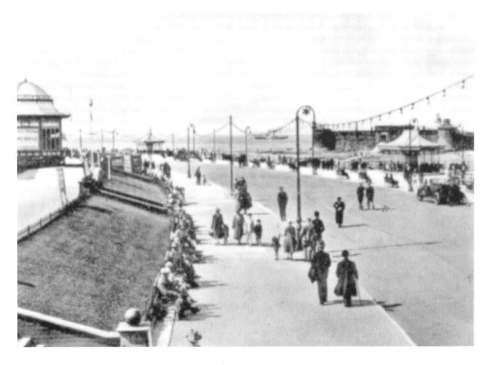

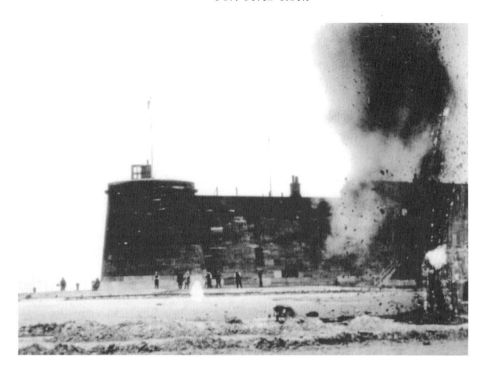

Above: Destroying an unexploded bomb outside the Fort on 30 April 1942.

Right: A new exhibit is wheeled into the Fort.

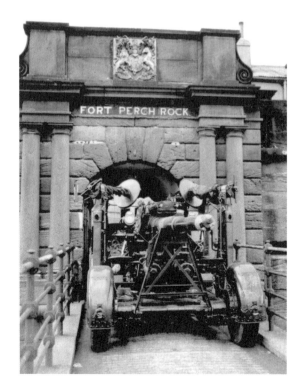

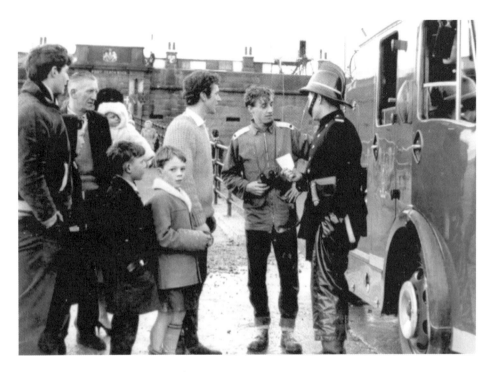

Firefighters carry out an exercise at the Fort.

CHAPTER 6

WALLASEY AT WAR

The proximity of Liverpool and the dock system meant that Wallasey would be in the frontline for attacks by German aircraft, and many bombs were dropped onto residential areas in the borough. The men and women of the Home Guard, Fire Service, Police and Wardens responded to the needs of the country to protect the local populace and its property. The first air-raid alarm sounded in Merseyside on 25 June 1940. Bombs fell on Altcar, Irby Thurstaston and Neston, but caused no damage or loss of life.

However, following a raid on Birkenhead the previous night, the bombs fell on Wallasey on 10 August 1940. Four people were killed, four seriously injured, and there was widespread damage to property. A small number of volunteer wardens were appointed on a full-time basis, but as the air raids increased all wardens were expected to give a greater amount of their time to the service. They would be responsible for checking and enforcing the blackout regulations, checking communal, Anderson and Morrison shelters, the gas cleaning scheme in private houses, the formation and the training of the Fire Guard, and the lighting patrol.

There were many acts of bravery and devotion to duty by the Wardens during and after bombing raids. They rescued people, some of whom had been buried under the debris, from burning and damaged houses. The Wardens had to locate and turn off gas and electricity supplies to limit the danger of explosions or fires. On one occasion they remained on duty continuously for forty-eight hours, during which time they were called on eighteen times to rescue people from bombed out buildings, and dealt with fifty incidents of incendiaries falling on properties.

In the first air raid of the war to affect Wallasey, on 10 August 1940, bombs fell on Adelaide Street, Cliff Road, East Street, Field Road, Florence Cottages, Gorsey Lane, Mill Lane, Ingleby Road, Stroudes Corner on Rake Lane, Palatine Road, Belmont on St George's Mount, Linwood Road, Wheatland Lane, Grosvenor Street, Lily Grove and Tulip Grove. There were thirty-two casualties that night and considerable damage to streets, houses, gas and water mains and the railway embankment.

Wallasey received most of the bombs that fell on Merseyside on the next raid, which occurred on the night of 30/31 August that year when high calibre and 1k electron-type incendiary bombs were used. The town was also bombed the following night when two people were killed and many others injured. The south-western corner of the town hall was hit, causing considerable damage to the organ and concert hall. Bombs also fell on the foreshore and the flour-mills on the Dock

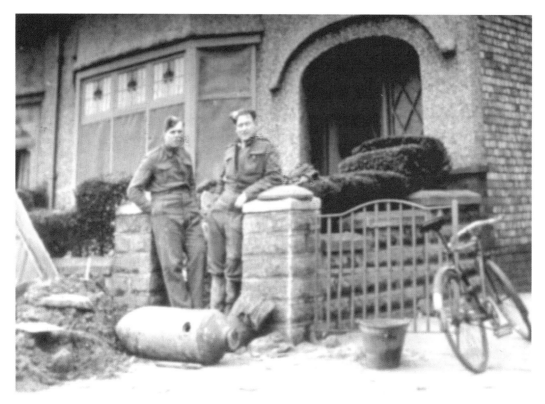

The Army UXB team works on an unexploded bomb in 1942.

Road. Raids followed on 5, 11, 22, 26 and 29 of September when High Explosive large calibre bombs fell on Southcroft Road, causing considerable damage to the area.

There were fifteen raids on Merseyside in October, when bombs fell fourteen times on Liverpool, seven times on Birkenhead, six times on Bootle and three times on Wallasey. There were fewer, but heavier, raids in November that year, with New Brighton being mainly targeted on the first day of the month, when there were eight casualties. Wallasey received a visit by the King and Queen on 5 November. They toured bombed areas of the borough and spoke to people who had lost their homes.

High explosive bombs which fell on 12 November caused damage to the Cheshire Goods Yard and Gorsey Lane Gas Works. The bombs that exploded and damaged property at Claughton Drive also broke windows half a mile away. There were approximately 100 raids to the end of November, and the total number of casualties on Merseyside were:-

	People killed	seriously injured
Liverpool	669	712
Bootle	44	82
Birkenhead	49	147
Wallasey	19	18

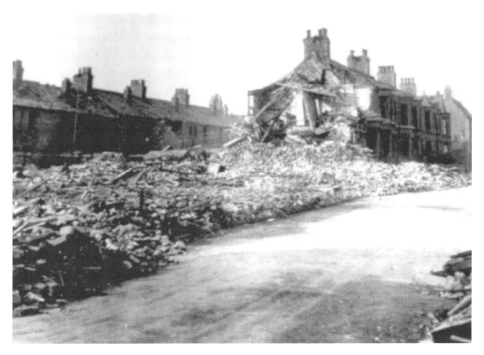

Houses damaged by the previous night's attack in Lancaster Road.

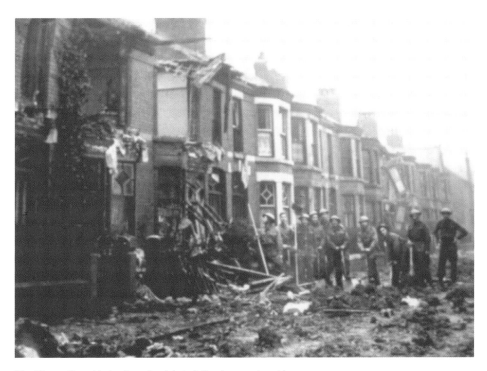

The Home Guard help clear the debris following an air raid.

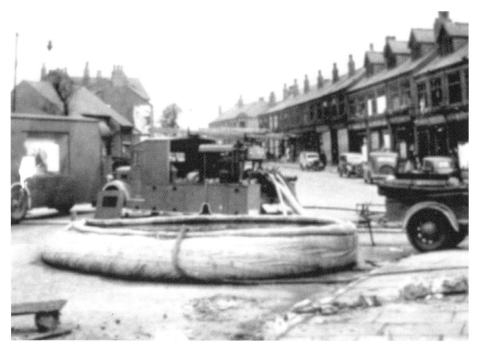

The emergency water supply in central Wallasey.

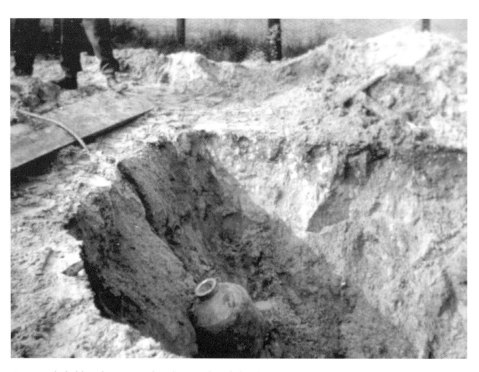

An unexploded bomb in Central Park is made safe by the Army in 1941.

There were few air raids at the end of November and the beginning of December, but some of the worst attacks of the whole war took place over the Christmas week that year, when 119 people were killed and 91 seriously injured in Wallasey. The night of 20 December was the longest night of the year, and the enemy aircraft came in waves. The bombing lasted for over ten hours. Over the three days of the 20th, 21st and 22nd, there were 121 people killed, 102 seriously injured and 156 other injuries.

On 3 January 1941 one of the largest bombs to be carried by German aircraft was dropped on Withens Lane, causing a crater approximately sixty feet across. Another, dropped on Wallasey Road the following week, caused a crater seventy feet across. The bombing on the nights of 12, 13, and 14 March 1941 were probably the heaviest of the war and the Victoria Central Hospital had to be evacuated because of the lack of gas, electricity and water. Electricity and gas supplies were interrupted, the pumping station at Seaview Road was severely damaged and total evacuation was considered. However, temporary repairs were made and services were gradually restored.

Following the three nights of bombing there was some respite for the people of the borough, as the next air raid did not take place until 8 April. There were no casualties, and on the 25 April Winston Churchill visited Wallasey to inspect the damage to the borough. A mine landed in fields near Bermuda Road on 27 April, and the docks at Liverpool were the main object of German bombers over this period. A large bomb fell on Wallasey on 1 May, but the docks and warehouses were worst hit, and considerable damage was caused during this attack.

In May, 1941 the casualties on Merseyside were:

	People killed	people seriously injured
Liverpool	1,435	1,065
Bootle	262	26
Birkenhead	28	44
Wallasey	3	19

New Brighton Cricket Club in Rake Lane was a direct hit in the raid of 2/3 May, and the majority of bombs dropped on 3/4 May were high-explosive, high calibre bombs, when Liverpool suffered its worst air raid. The Brocklebank Line cargo vessel *Malakand* was loading ammunition in Huskisson Dock when incendiary and high-explosive bombs set the adjacent shed on fire; it spread to the ship and she blew up. The Wallasey ferry, *Royal Daffodil* sank at Seacombe Landing Stage on 7/8 May. There were no casualties following the air raid on 31 May, but there was extensive damage to property on 1 June, when Warden W.J. Smythe lost his life. The raid of 25 June caused much damage, and one person was seriously, and one slightly, injured. Bombs were dropped in the Irish Sea, off Harrison Drive on 20 October, and others dropped into the River Mersey the following night. Heavy rain fell on the night of 1 November, when bombs fell and gas, electricity and water services were temporary disrupted. On 10 January 1942 the last bomb fell on Merseyside.

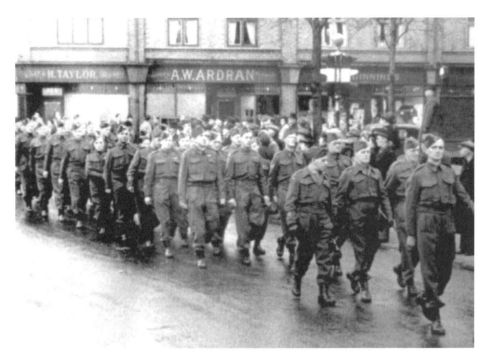

The Home Guard march through Liscard.

Water was pumped from Central Park during air raids when the water mains were damaged.

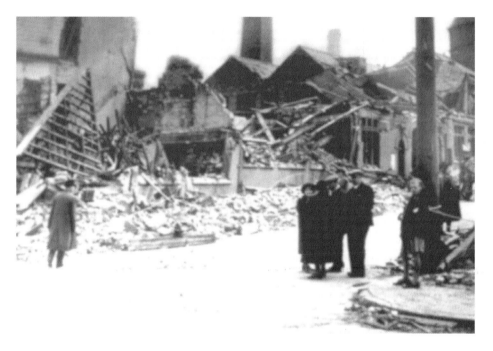

Workers congregate at the gates of a factory on the Dock Road, which had been damaged the previous night.

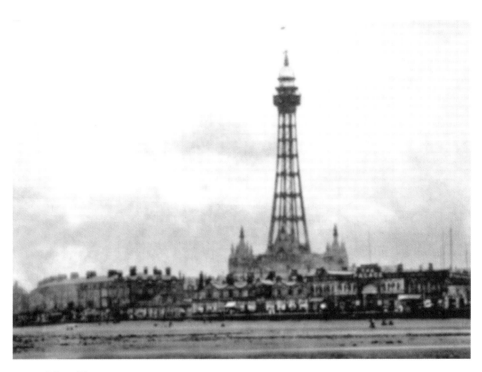

New Brighton Tower.

CHAPTER 7

NEW BRIGHTON TOWER

Work commenced on building the Tower on 22 June 1896, and it was completed in 1900 at a cost of £120,000. The Tower was 567 feet 6 inches high, and it was 621 feet above sea level. The architects for the project were Maxwell & Turk of Manchester, and it was built by Handysides & Co. of Derby

The New Brighton Tower & Recreation Company was established with a share capital of £300,000, and an area of twenty acres at the Rock Point Estate was purchased. The idea was based on the Eiffel Tower in Paris, and it was to be 544 feet high, with Assembly Hall, Winter Gardens, Refreshment Rooms and a cycle track. The Tower was to be more elegant than Blackpool Tower, and £1 shares were offered to investors.

There were six workmen killed during the construction of the building and others seriously injured. It was the highest building in the country on completion, and suffered its first suicide shortly after it was opened when a man threw himself off the balcony. It cost 6*d* to travel to the top of the Tower by one of the four lifts, and it was possible to see the Isle of Man, Great Orme's Head at Llandudno, the Lake District and the Welsh Mountains. Half a million people visited the Tower in the first year it was open.

The Tower Ballroom was one of the largest in the world, with a sprung floor and dance-band stage with sufficient space for over sixty musicians. There was space on the dance floor for over 1,000 couples, and it was initially decorated in white and gold with emblems of the various Lancashire towns. It incorporated a balcony, with seats to enable people to watch the dancers below, and a large area where couples could learn to dance. The Beatles played at the Grosvenor Ballroom in Liscard in 1960, and on 12 October 1962 they played at the Tower Ballroom as the support act for Little Richard. The billiard saloon contained five billiard tables, and there was also a monkey house and aviary in the elevator hall, which also contained a shooting gallery.

The Tower gardens covered an area of thirty-five acres, with a Japanese café at the side of the lake which had gondoliers and Venetian gondolas. The gardens also had a fountain, seal pond in an old quarry and a rockery. Visitors could watch the pierrots from the Parisian Café and there was an outside dancing area which could hold a thousand people where a military band would also play.

There was a high wire above the dancing area for tightrope walking, without a safety net. The tightrope walker, James Hardy, bet another man that he could walk across the rope with a girl

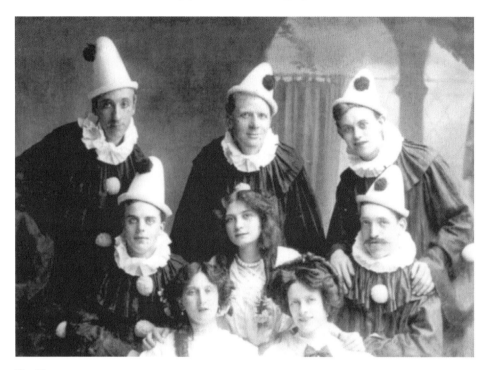

The Pierrot group.

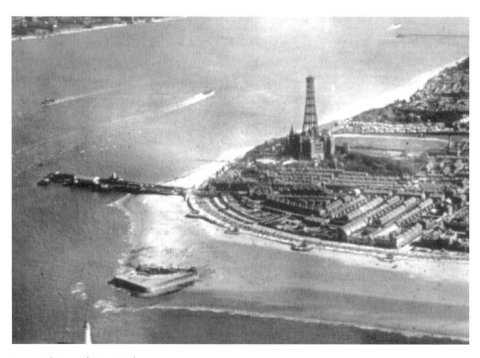

An aerial view of New Brighton.

on his shoulders. It is claimed that he won the bet by carrying the barmaid from the Ferry Hotel across the rope on his back. The outside space was also used by visiting orchestras who also played in the theatre in the afternoon. The Rock Point Castle Restaurant was surrounded by trees and pathways and the whole area of the Tower grounds was patrolled by the private police force of fifteen men.

An old English fairground was provided on a higher level which later became the coach park. There was also a Himalayan switchback railway, and water chute with boats travelling at speed into the lake. The railway was originally an exhibit at the Brussels Exhibition, and the lion house contained Prince and Pasha, two Cape lions. A menagerie of a variety of other animals was also provided.

It was claimed that the theatre had the largest stage in the world, which measured forty-five feet wide and seventy-two feet deep. It could hold 3,500 people, and was built instead of a giant wheel that had been in the original plans.

There was an athletic ground at the rear of the Tower building which had a football ground in the centre. It also had a cycling track around the edge where cycling championships were held with the World Cycling Championship being staged there in 1922. Motorbike racing was also held at the track. A large American roller-skating rink with bazaar and shops was very popular and admission was one shilling, which included admission to the Ballroom and theatre. The New Brighton Tower Football Club was founded in October 1896 and played against the other fifteen teams in the English League.

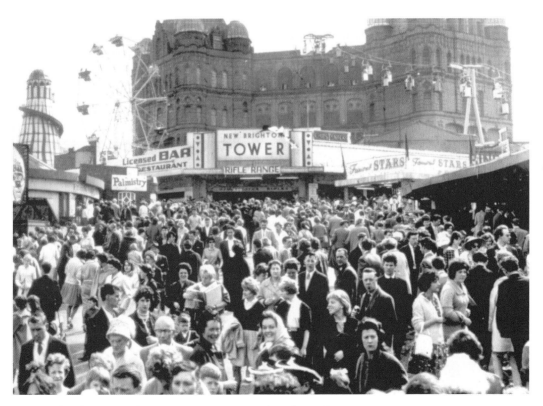

Weekend visitors at the Tower Amusement grounds in the 1950s.

Various shows were held at the Tower grounds, including the troop of seventy Bedouins, Arabs and Dervishes in 1901 and a show by the Abyssinian Warriors in 1907. In 1908 the Wild West Show took place at the Tower grounds, with 500 cowboys, cowgirls and their horses. The show contained US Artillery, shot rifle displays, cavalry men, Cossacks, Indian warriors, chariot drivers, acrobats and contortionists. As American cattle were not allowed to be imported into the country, wild highland cattle were brought from Scotland. The cowboys would fire their guns on the promenade and lasso the female visitors. The Indians were eventually banned from the New Brighton public houses after sampling the local 'fire-water'.

As there was very little maintenance work carried out on the Tower during the First World War, the steel structure was neglected and became rusty and very expensive to repair or replace. Consequently, it was decided to dismantle the Tower, with work commencing on 7 May 1919 and being completed in June 1921. The main building, comprising the Ballroom and Theatre remained, and during the Second World War the basement was used as an air-raid shelter.

The Tower and the Tower grounds and fairground continued to be popular following the Second World War and into the 1950s. Many of the Mersey Beat groups entertained at the Tower, including the Beatles. However, the greater prosperity of the early 1960s meant that people were able to travel further for their holidays and leisure-time activities. The rise in car ownership was reflected in the drop in people using the ferry to New Brighton, and the popularity of such seaside resorts was reduced.

On 5 April 1969 the Tower was destroyed by fire, leaving the shell of the building which was later demolished. The site was grassed over, providing a recreation area for the community and the old athletic ground was purchased by a property developer and a housing estate was built on the site.

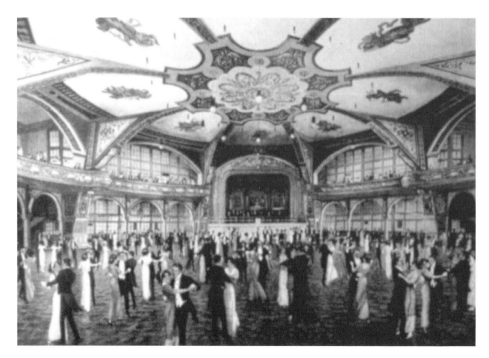

New Brighton Tower Ballroom.

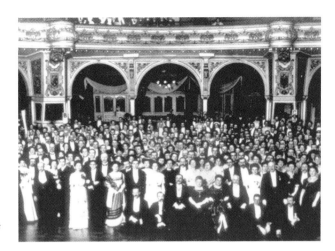

Wallasey Mayor's Ball in 1912 at the Tower Ballroom.

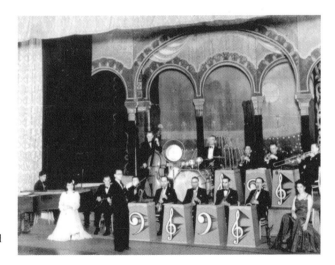

Bert Yates' Band entertains at New Brighton Ballroom during the Second World War,

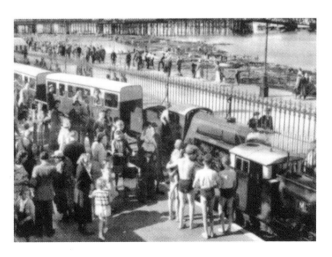

Tommy Mann's 18mm miniature railway operated from 1948 until 1965.

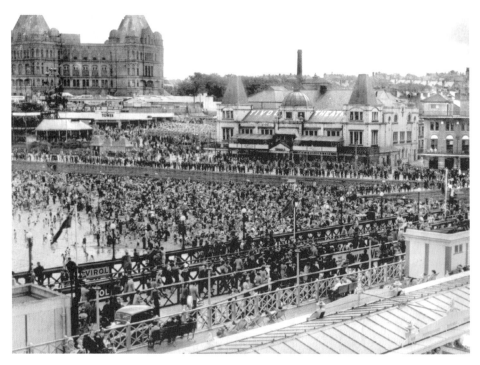

This page: Crowds of visitors enjoy a fine summer's day in New Brighton in 1958.

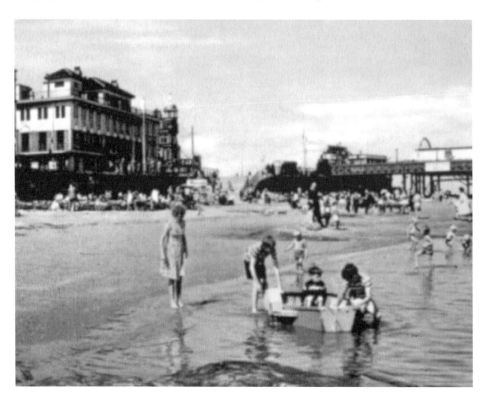

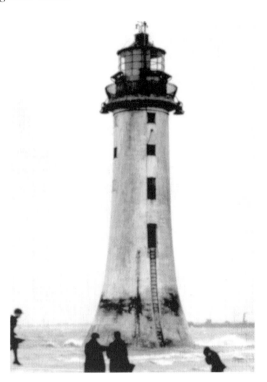

Right: New Brighton Lighthouse in 1955.

Below: The Mayor of Wallasey enjoys a ride on the new chairlift in the Tower Grounds on 18 April 1960, when it was officially opened.

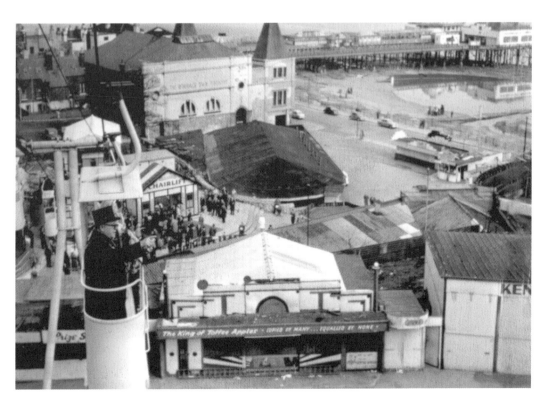

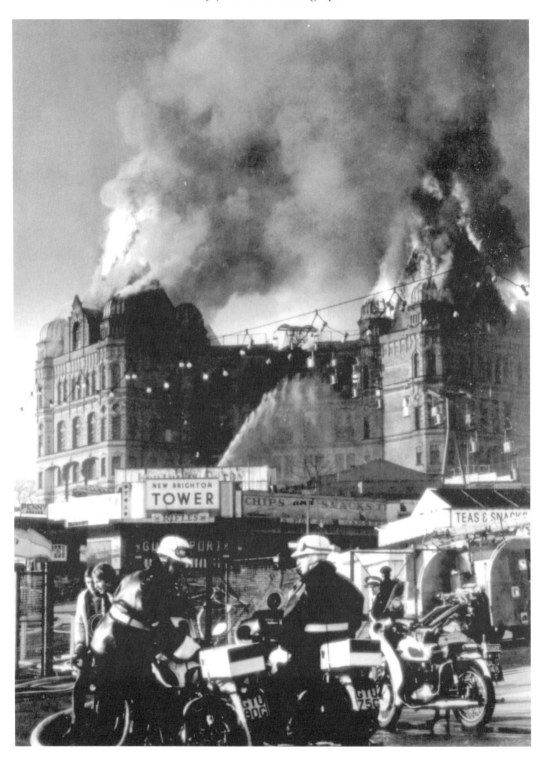

The fire which destroyed the Tower on 5 April 1969.

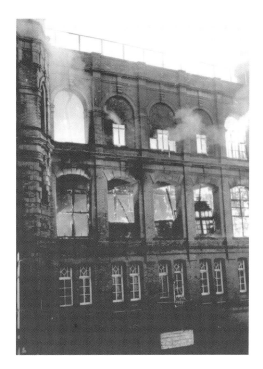

Right: The fire takes hold and gradually burns through the building.

Below: Damage to the Ballroom is inspected by fire fighters on the day after the fire.

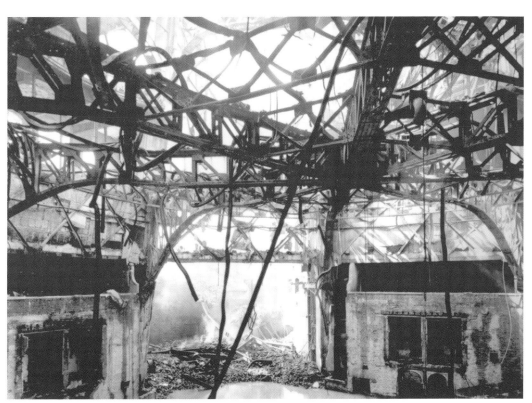

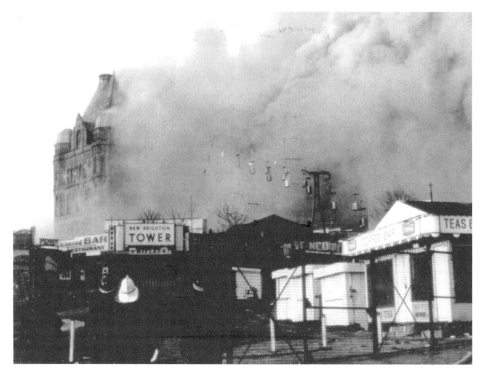

This page: Fire-fighters attempt to save the building.

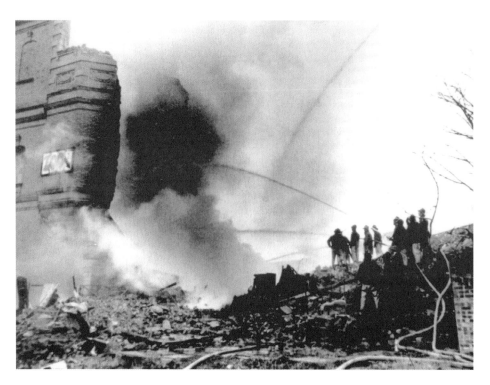

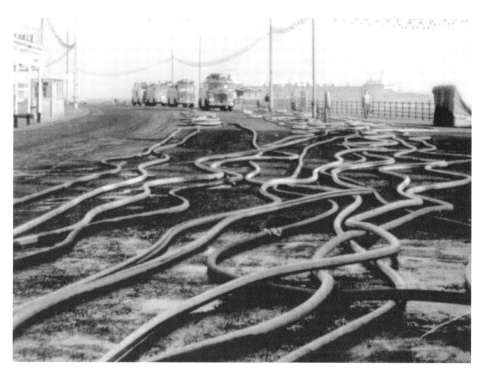

The hoses and fire engines on the Promenade on 6 April 1969.

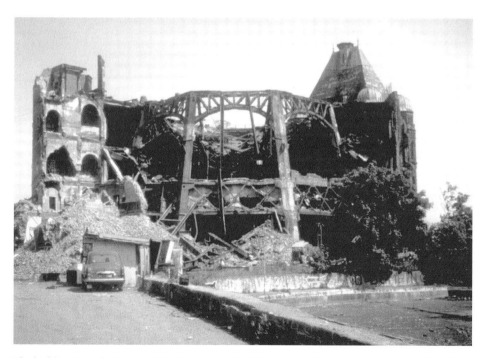

The building is gradually demolished in the months following the fire, during the summer of 1969.